T0150739

A1

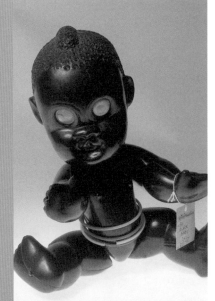

DigNative

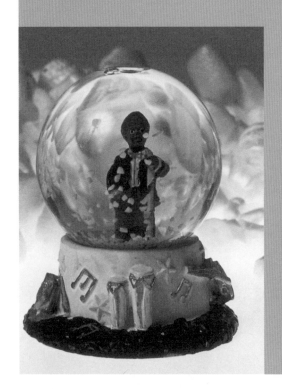

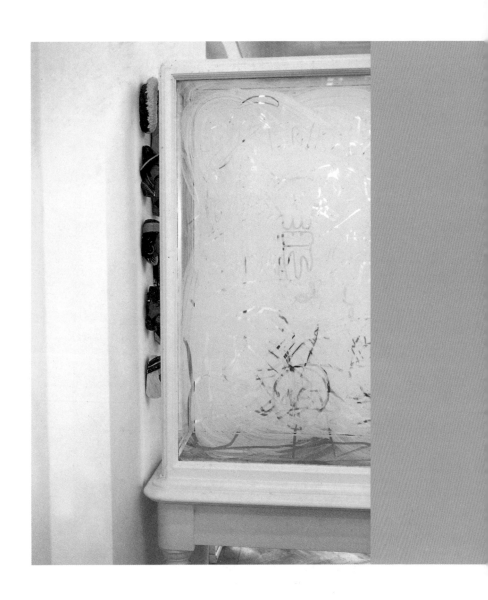

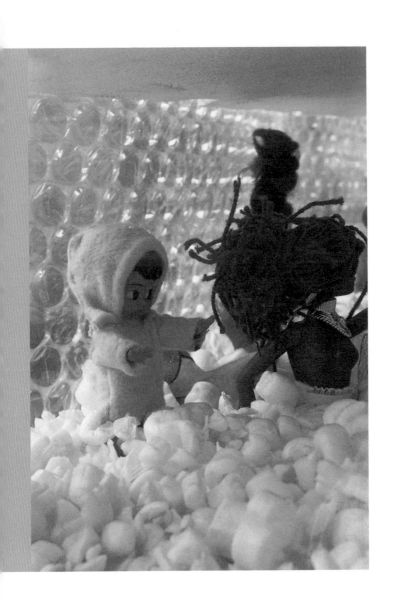

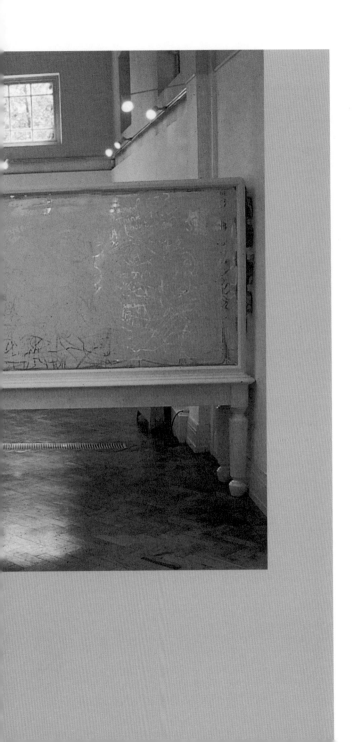

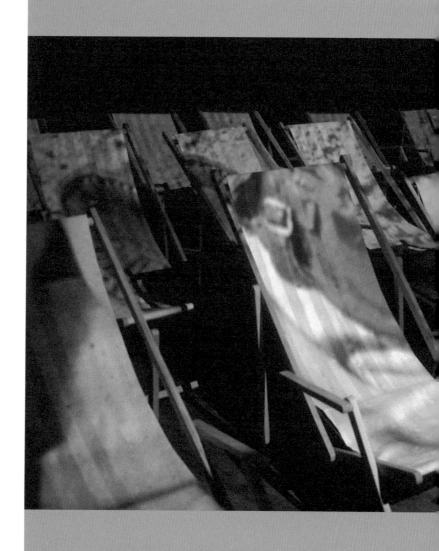

Going Native

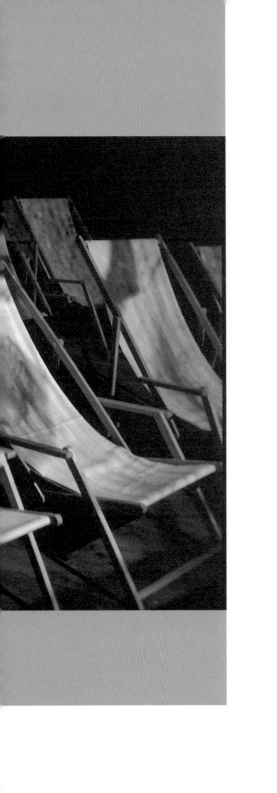

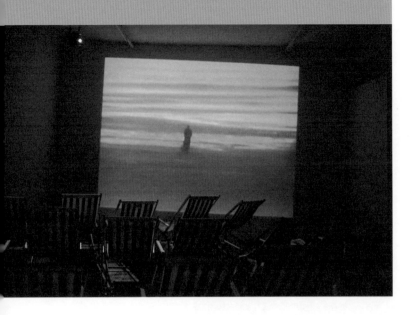

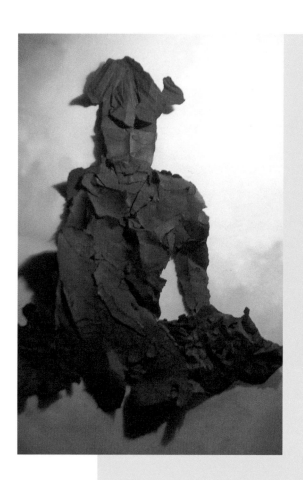

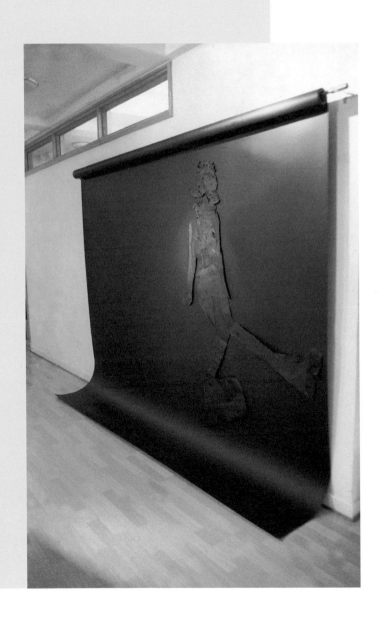

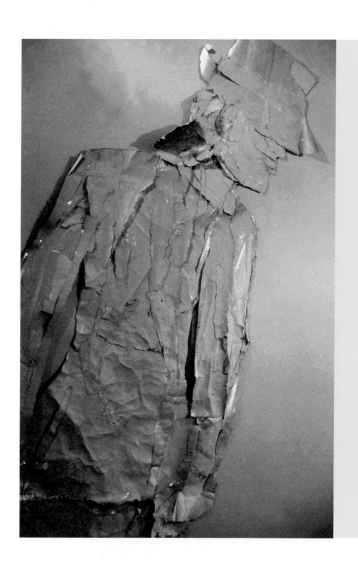

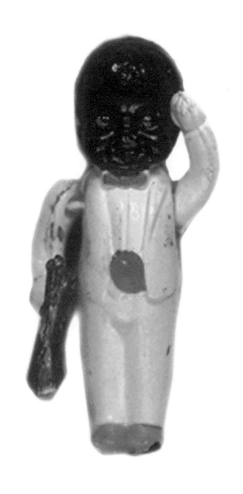

Object Collection

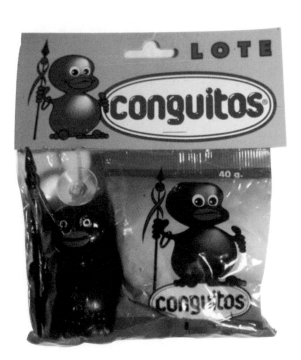

After the Deluge

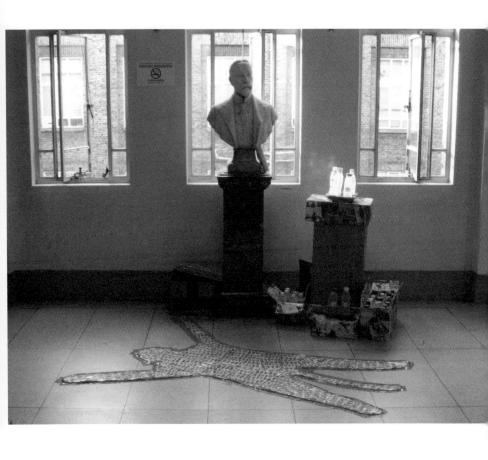

Fire, Theft and Acts of God

Confrontations

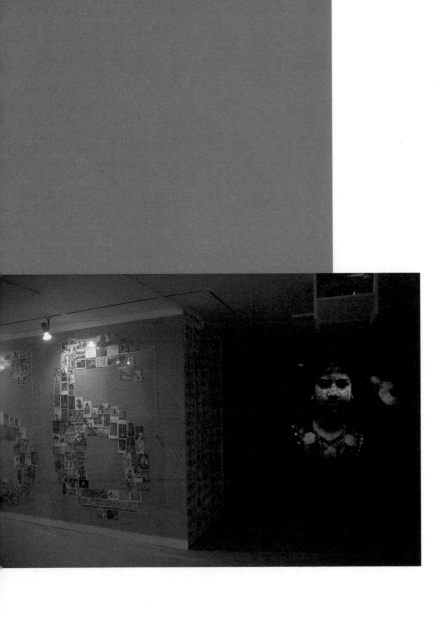

A25

Its cheap to run

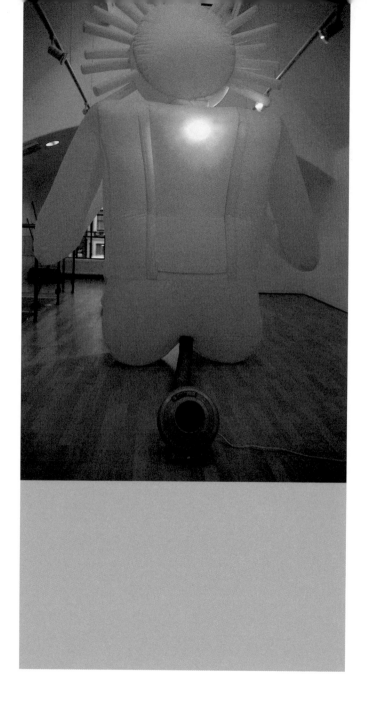

Introduction Dave Beech

Shaheen Merali is an artist who puts popular culture through its paces. He is, as you will see in this collection of essays and works, exercised specifically by the racial and racist content of popular culture. This does not involve Merali pathologically encoding popular culture with the themes and issues of his own choosing — that is, simply 'reading-in'. The politics is in there. Since the value of Merali's entire project is predicated on the always-already presence of the politics he discloses, I want to use this introduction to explore what exactly this relationship is between politics and popular culture.

Let me begin by clarifying what I mean by politics being in culture. There are two kinds of 'in' that I want to distinguish. A pebble is in your hand only so long as it retains that relation to your hand: let it go and it will fall: an egg, on the other hand, is in a cake more radically speaking — if you have the cake, you have the egg. The philosophical term for the latter kind of 'in' is immanence; this is the sort of 'in' that is germane to the question of the relationship between politics and popular culture: politics is immanent to popular culture.

I will shortly give a small number of examples that I think show how politics is folded into popular culture. First, I want to address the question of Merali's use of popular, mass or commercial culture in his politicised art.

Popular culture is not a soft target for Merali, as it can be for others. He has no ill will against the popular as such; nor does he seek to raise popular culture to the level of art. In other words, Merali does not score political points off a weak opponent. On the contrary, Merali takes popular culture very seriously indeed. In fact, he loves it. It becomes clear through Merali's work that the most trivial objects of

amusement carry an inordinate wealth of history, knowledge and prejudice. What is to his great credit, therefore, is that Merali can smell a bad egg in the most delicious of cakes.

Let me explain without excusing myself. I want to describe my formative experiences of racism; my earliest encounters of racism and my formation through racist attitudes. At Primary school I thought the words 'Jew' and 'Jewish' were simply slang for someone who was stingy. There were jokes about the stinginess of the Scots, but if someone held onto their sweets, you wouldn't say, 'don't be so Scottish'; you'd say, 'don't be such a Jew'. I don't think any of us knew what a Jew was. Nevertheless, we knew that a Jew was stingy.

As a kid, I thought Teddy Bears were sissy, so I had a golliwog instead. It was, with hindsight, a straight swap: (to put it crudely) sexism for racism. I recognised the stuffed golliwog in the shop from the jars of jam. I don't know whether I liked the golliwog because I liked the jam, or if I preferred that brand of jam because of the friendly face on it. What I do remember is that the stuffed golliwog wasn't as appealing as the picture and I didn't keep him for long. He was, nonetheless, my first intimate contact with a racial codification that I was a long way from formulating.

Nigger was the name of my Nan's dog. There was nothing hateful about the name; the dog was dearly loved. There was no irony either and no insult intended towards the dog. He was called Nigger because he was black. That simple fact, at the time, seemed enough. In other words, black connoted nigger effortlessly. Nigger was part of everyday speech and everyday thought; an unremarkable observation: the closest thing to a fact. Like the

conflation of Jew and stinginess, then, the use of the word 'nigger' in reference to something black, in my experience, preceded any direct or noticeable racist use of the term.

Racism, sexism and bigotry were everywhere in my childhood. They weren't swept under the carpet or shoved down your throat; they weren't highlighted or hidden: racism, sexism and bigotry were commonplace. Instead of the liberal dream of a 'blindness to colour', my childhood was, like many others I suspect, shaped by 'blindness to racism'. The racism that was everywhere was in another sense nowhere. Racism was, in effect, already in the language that you learned. You didn't learn racism in addition to learning everything else: it was built in.

Oddly, then, racism seemed to have nothing to do with our use of terms like 'nigger', 'golliwog', 'Paki' and 'Jew'. This is because the racist connotation came first; the denotation of a race later. So that by the time you discovered that the words 'Jew' and 'Jewish' referred to a people, or that nigger and Paki were terms of racial abuse, you already 'knew' something about 'them'. Or, if you like, before you were aware that eggs were in the recipe, you already liked the taste of cakes.

Merali is acutely aware of how popular culture is a special kind of carrier of social prejudice and invective just in the way that I have outlined. Consider his series of life-size black paper constructions of black celebrities such as Naomi Campbell falling off high heels at a Vivien Westwood catwalk show. This set of works retrieves images of famous black individuals from the moment of their well-publicised fall. Collapse and shame spectacularised in the media is met with the dignity of scale while the blackness of the people is underlined with the silhouette cutout

format made entirely of black paper. Euphemism is blasted with what amounts to a mixture of structural analysis (mapping the trope of the fallen black celeb) and pride (re-emphasizing blackness and human scale). There is enough power and emotion in these images to take us beyond the recognition that racism stinks; they steal dignity and pride back from ignominious, aggressive trivia.

To argue, as I am doing (and as Merali's work does, in its own, necessarily different way), that instances of media coverage of the ridicule of black celebs in trouble has racist content, is to go against moderate thinking. The moderate thinker would assume, on the contrary, that all celebrities are subject to this sort of attention; that fame, especially in the English press, is a cue for the grottiest forms of spitefulness; that, as the media describes itself, the press builds you up only to drag you down again. Pride comes before a fall, the tabloids demand, irrespective of race, then? It has a ring of truth to it, which is an essential ingredient for moderates. However, what such a view leaves out is the racism and racial codes that have been folded into the culture in advance of the iteration of banal celeb bashing. How can two episodes of famous decline, one white and one black, be regarded as identical in a culture unevenly divided by race?

In assuming that race is irrelevant unless it is deliberately raised, the moderate turns the world on its head. From the moderate's point of view we need to explain the source of the racism of each instance of the representation of individuals separately, hence the assertion, above, that two individuals of different race will not fall identically in a culture divided by race. Actually, the point would be clearer if we asked the inverse question: how can the declines of these two celebrities be considered

outside of racial division and its concomitant abuses? Following from this, it is not stretching things to suggest that a black celebrity and a white celebrity do not, in fact, fall in the same way at all. Michael Jackson, who also appears in Merali's black collage works, typifies the impossibility of equal treatment across the division of black and white by virtue of the widespread perception that he has cosmetically engineered the shift from black to white. It is as if the whole cultural weight of racial division descends on Jackson as a result of this 'fall'. The traditional Afro-American minstrels, who would 'black-up' if they appeared too light for a white audience, were turned into a figure of shame for black activists; Jackson's alleged 'white-up' is shocking in its way because it both confounds and lives up to racial stereotypes simultaneously. This predicament provides the tension in Merali's political and cultural project. Instead of promoting black politics, Merali attends to the impassable paths of racial conflict through the traces they leave in cultural material.

The impassable path that Merali dwells on is, as the phrase suggests, strongly linked to the deconstructionist object of analysis: aporia. Jackson's impossible predicament is, in Paul de Man's sense, a radically undecideable trope. As such, the desire to resolve the predicament in a single statement, interpretation, position or whatever, betrays a flight from complexity, and must result from an authoritarian imposition of one reading over another. Aporias are impassable paths because they cannot be reduced to a single, non-contradictory state. In the political frame that I am emphasizing here, this means refusing to resolve the architecture of racial conflict at the level of the single act or event.

Jackson's predicament is not impossible on the grounds that the pop star is

disingenuous, dissembling or deceptive;
it is aporetic because it is subject to
social fissures that are exacerbated at
every turn (you're damned if you do, and
damned if you don't, and all that).
Socially, then, aporias are the impossible
predicaments in which individuals are
the (often unwitting) vehicles of
political contradictions that cannot be
resolved at the level of the individual
suffering them.

When I argued, earlier, that racism is in
culture, I was aiming at the difference
between the moderate view (with its
ring of truth) and the radical view
(which appears to stretch the truth).
The reason that I described racism as
in culture, not merely added to it; and
that racism precedes culture, or gets
into it in advance, can now be stated
more clearly: culture (representations,
utterances, iterations, and so forth)
cannot be split from social relations
(divisions, hierarchies, hostilities and so
on). Under such circumstances as are
prevalent today, racism is not the
exception; it is the rule. The moderate
assumption that racism raises its ugly
head only when highlighted by minorities
(by racists or radicals) is a false
assumption. Racism, like sexism and
homophobia (amongst others), trips us
up with our embarrassing gaffes, slips
of the tongue and irrational pleasures.
As such, racism is, in a politicized
reading of Freud's famous formula,
part of the pathology of everyday life.
And it is in everyday life that Merali
seeks out racism. It is not his fault,
but ours collectively, that he finds it
in such abundance.

Dark
Matters
Hito
Steyerl

The Viennese like black people. Especially if they are made of chocolate and edible. Chocolate sweets in the form of black faces were served as snacks by the gallery Kunsthalle Exnergasse during the opening of Shaheen Merali's exhibition 'Dark Matters'. In his investigation of local products, Merali has identified these Viennese candies from the various items which are constructing a habitual and daily practice of negrophilia/phobia. He has photographed and framed their innocent and vacuous gaze, the jolly and exuberant smile on ultrapink lips made of sugar.

In Vienna black people's heads indicate palatine pleasures, exotic food, and devout service. The head of an imperial moor servant serves as a logo for a supermarket chain. Another famous black person made a surprising career after having been imported as a slave to the Viennese Imperial court. He became a respected member of the gentry. So singular was his existence, that he was stuffed after his death and exhibited at the National Museum of Nature until WWII.

Nowadays the imaginary relationship of most Austrians with Black people is mediated by sugar in another sense of the word, namely by drugs. Large Austrian tabloids have mounted racist campaigns denouncing Blacks as drug dealers, ready to seduce and poison innocent Austrian children. Massive police raids against refugees did not produce any considerable amount of drugs, but have created a chilly and hostile atmosphere towards Black people. The Viennese Black Community suspects that the drug raids were aimed directly against the rising political movement of Black people against daily harassment and police racism.

My feelings are therefore very ambivalent when I see the crowd of exhibition visitors happily munching away at the negroid candies. Obviously the staff thinks that it would be a funny idea to offer those sweets for public and collective consumption. They seem to assume, that to eat these cakes would mean an ironic antiracist statement, that the visitors might prove their tolerance by simply consuming a black person's head, thus simultaneously enjoying and annihilating their sweet flavour. It strikes me that this is precisely the Austrian handling of immigration, its understanding of integration and so-called tolerance. What we are witnessing is in fact a demonstration of assimilation in Austrian style. The German philosopher Hegel has discussed this interpretation of assimilation. To assimilate something was for him equal to eating and digesting it. According to this

interpretation, efforts to achieve equality can be replaced by simply consuming whatever Black people have to offer, their food, their raw materials, labour power or even their candy effigies. No other effort is required, but a complete candid ignorance about what one is actually doing.

This anecdote points at the main issues raised by Merali's exhibition in Vienna: popular racism, and the difficulties of translation between different contexts. As we will see, both issues were highly influenced by the massive political changes in Austria in Feb. 2000, when the rightwing populist Freedom Party entered the Austrian government. Hundreds of thousands of protesters were crowding the streets for weeks. The seat of the government was under siege. It certainly is a very rare coincidence to open an exhibition dealing with racism in popular culture at exactly the moment when the most outspoken representatives of this type of popular racism are entering the government and hundreds of thousands of alleged antiracist protesters are crowding the streets. This was the case with Dark Matters. And in this setting, not only the artworks but also the whole setting of the exhibition itself became immediately highly politicized and acquired new and unpredictable meanings. It became not only impossible but also counterproductive to estimate where art ended and politics began. Therefore I will not only describe the exhibition as such, but also the controversies and debates created around issues such as the role of visual culture in politics and its possible effects concerning racism and oppression. But lets first take a look at the exhibition itself.

The focus of the works Merali displayed in Vienna is the intersection of popular culture and racism and the exposure of their mutual dynamics. Both are condensed within items called dark objects by Merali. Those dark objects are objets trouvés, racialized trifle such as flowerpots, pseudo folklorist souvenirs, and the like. In the series 'digNative' he uses small toy figures representing people of colour to arrange tableaux of social relations. Black and white toys are confronting each other as policemen, tribespeople and other social characters. Merali explores the relationship between racist desire and disgust, between consumer goods and art fetishs, between the sweet icing of kitsch and brutal racist violence in several variations. On one hand, racial kitsch is industrially produced by a logic of

multicultural consumption driven by neurotic repetition. On the other hand, it serially reproduces racist desires. The visitor's reaction exemplifies this logic of commodification and consumption. Their reaction to the confrontation with Merali's analysis of racialized consumer products was to keep on consuming. In fact this reaction is far from irrational or naive, since it simply reproduces the reactions of Western nation states towards their minorities and immigrants. They are being transformed into tasty and desirable products of cultural difference. Thus they become suitable for assimilation, consumption, exploitation and digestion.

But Merali doesn't simply stop at exposing those dark objects. He is questioning them. Any type of object can become a dark object, if put into a relevant context. By combining it with video footage of Jesuits walking down the beach of colonial Goa, Merali transforms Mozart's Requiem into one of these dark objects. It is a part of the installation Going Native. A large video projection shows a trail of monks clad in black, behind them the vast blue sea. The film is seen from deck chairs which position the spectator as a tourist. The image is devastatingly beautiful. It draws viewers into a violent genealogy of Portuguese colonialism. The Portuguese were the ones who first transformed physical desire into an instrument of racist and colonial subordination through an almost scurrile caste system of half-, quarter-, and five-eights Portuguese subjects. Merali's installation hints at this historical background in a mediated way. In Goa, too, the pyres of inquisition were ablaze, run by European monks surveilling the moral norms of the colony. Mozart's triumphant music of death and redemption, written in Vienna, accompanies their peregrination.

Thus, Merali positions his dark objects within social and historical relations. His approach can be characterised by two terms: first the notion of the constellation. Adorno wrote: 'To become aware of the constellation in which an object is positioned, means to decipher the one, which it carries within itself as a historical formation.' The investigation of the environment of an object is crucial in order to understand what it means, and how this meaning has been structured and constructed. The spatial terms of the constellation are addressed in Merali's works as its setting, as a questioning of the conditions of visibility and meaning, especially in an art context.

The showcase is for him a privileged object, which
repeatedly serves as a stage for racist
constellations. The items contained within are
fetishized and elevated to the status of ritual
objects. But on another level, this process is called
into question. One part of the installation digNative
for example consists of a diptych of two show-
cases, smudged all over with white cold cream and
therefore blurring the sight of grotesque busts of
black people hidden within the glass case. If the

viewer attempts to get rid of the white veil
obscuring the gaze, by trying to rub off the cream
from the pane, the prospect becomes even more
opaque. What becomes visible on the pane instead, is
the inscription of voyeuristic energy, the trace of
neurotic white desire itself. The showcase thus
becomes a projection screen where otherwise
invisible racist drives are being actively inscribed,
while their object remains blurred and indeterminate.

Another constellation was exhibited at the same time
at NGBK gallery Berlin. The installation Channels,
Echoes and Empty Chairs arranges racialized objects
into absurd compositions, displayed as photographic
transparencies. Cocktail sticks in the form of
exaggerated black heads are used to acupuncture a
naked back. A South-Asian lady looking reproachfully
is projected on top of the chaotic combination. A
playful commentary by the artist announces that on
this date, a certain astrological constellation had
blocked his energy flows so effectively, that
western-saturnic melancholia had to be liquefied by
Chinese acupuncture. The cocktail sticks thus become
a treatment to revitalize the flow of individual
energy. But what kind of energy is this? In another
text, Adorno pointed out the specific meaning of
constellations in astrology. His infuriated essay does
not even attempt to criticize astrologic systems of
belief for their evident irrationality. Instead he
focuses on their function of replacing social and
political causality by fate. Since everything is
determined by destiny, there is neither a need nor
even a possibility to change the status quo. The same
goes for racism as a system of belief. Since cultural
or biological laws determine all social relations, the
status quo is deemed irremediable. Both astrology
and racism thus function as fatalist systems of
depoliticization. In Merali's installation, this emphasis
on social relations is explicitly being highlighted. His
combination of different motives begs the question
about which forces are organizing racist

constellations? Fate? Stars? Private fancies? Politics?
Which powers are at work here? Which forces shape
desires, suffering and crime?

Since the notion of context and social relations are so
important for Merali's work, it is not surprising, that the
exhibition itself immediately started to resonate with the
political developments in Austria. Suddenly, the exhibition
acquired a far broader meaning than the already complex
meanings suggested by the individual works themselves.

Dark Matters was turned into a part of a larger political
constellation – so that its effects could be determined
only by considering its environment. But what exactly
happened during this agitated period of February 2000?

Just a few weeks before the opening of the exhibition a
new coalition government had been appointed in Austria.
It consisted of a coalition between the conservative

Austrian Peoples Party and the right wing Freedom Party
under the leadership of Joerg Haider. This outcome
came as a shock to many people. The Freedom Party is
well known for its right- wing position and their leader
Haider once had to resign from the post of Carinthia's
prime minister, as he publicly lauded the labour policy of
the Third Reich. Now this party was in power. For weeks,
Vienna had been bustling with opposition activities. The
new government had assumed its responsibilities under
an unprecedented wave of protests on a national and
international level. On the day of the appointment of
the government, the ministers had to pass an

underground tunnel in order to reach the location of
the ceremony, since access was blocked by a passionate
crowd of mostly young demonstrators. In February
2000, protests were being organized on a daily basis,
flowing across the snowy city in unorganized and

spontaneous patterns. Oppositional websites and
stickers were being designed, and outdoor clubbing in
front of the government seat had become a fashionable
habit among Vienna's young urban demonstrators. Many
of the art institutions in Vienna were actively
supporting the protests and hosting discussions and
meetings. While the atmosphere was spontaneous,

cheerful and creative, the level of political analysis was
not overly acute. Since nobody knew now what to
expect from the unexpected situation, speculations
and fears were running high. While public opinion abroad
is mainly concerned with the possibility of a revival of
classical Nazism, inside Austria people were above all
confused. Who is going to be the first target among the
groups which the Freedom Party has repeatedly bashed
and ridiculed during its campaign? Migrants? Artists?

The liberal press? Women? Bureaucrats? Or rather the welfare state as such? In any case, the European Union members preventively decided on implementing a noticeable chill of diplomatic relations with the Austrian government. The reasons for these measures, which became publicly known under the disproportionate title 'sanctions', were based on a moral condemnation of the Freedom Party's affinity to fascist positions. In fact, this assessment also reflected the attitude of the majority of the Austrian opposition. Since nobody knew what to expect from the present, most people turned to the past in order to explain the unprecedented situation. The fear of a possible return of the fascist dictatorship offers at least reassuring historical certainties. Instead, the opposition had to grapple with the unsettling phenomena of the unpredictable and resourceful political opponent Haider promoting racism by behaving like a pop star and embracing the concepts of both the welfare state and neoliberalism simultaneously. So when the self-proclaimed 'resistance' movement chose antifascism and antiracism as main protest issues, this choice was rather motivated by the lack of political analysis. The concept of antiracism was especially unclear. Although most protesters enthusiastically endorsed the issue, hardly any of them seemed to notice the Austrianness of their own movement, from which immigrant positions were consistently lacking. Antiracism was rather understood as paternalistic sentimentality, a call for 'tolerance' towards people whose rightless status was otherwise fully accepted. Especially the Socialist Party which had backed some of the large protest demonstrations seemed quite hypocritical in its attempts to promote antiracism: during its rule it had installed one of the most racist legal systems within the European Union as well as a police force which was routinely mentioned when it came to racist violations of human rights in police custody. What was at hand therefore was a highly problematic notion of antiracism which was nonetheless powerful enough to mobilize hundreds of thousands of demonstrators. One could say that this notion functioned not in spite of the ignorance of the protesters, but precisely because of this ignorance – just as was the case with the visitors of the gallery who loved to consume the negrophile candies. Antiracism functioned as a rallying cause because it seemed so remote from the protester's

practical interests that basically the whole opposition movement was able to subscribe to it – as long as it remained white and Austrian. And this remoteness was so substantial that the protesters never even noticed, that Black activists used to call them the White resistance.

This was the political context when Dark Matters opened at the gallery Kunsthalle Exnergasse in the end of Feb. 2000. Given the heightened attention to political issues at that point, the exhibition drew quite a lot of public attention and immediately became a kind of acupunctural nod of political and artistic energy, a site of contestation for different debates about arts, politics, the distribution of power and racism. One of the debates was a discussion about the appropriate reaction of the artworld to the political events in Austria. The question was whether artists from abroad should boycott Austria or not. Should something like cultural sanctions be imposed on Austria? Opinions were divided on that point. While some curators and artists, mostly from outside Austria, held the opinion that political pressure should be kept as high as possible, most Austrian protesters were opposed to the boycott since they felt that they – and not the conservative mainstream – would be the ones to be isolated from the international circuit. Although the reasons for boycotting Austria were doubtlessly morally consistent, actually Merali's exhibition proved the last point to be equally true. Two persons invited to the accompanying symposium of the exhibition cancelled their presentations for political reasons. It was his exhibition, which was explicitly devoted to questioning racist systems of signification, which turned out to be one of the few ever boycotted. Had he known this, I am sure that Haider would have chuckled. One of the boycotters, Niru Ratnam, gave perfectly understandable reasons for his decision not to come to Austria. First he pointed out, that protest confined to an art gallery could easily turn out to be sanctioned protest, an outlet for anger within a system of repressive tolerance. But secondly, he expressed his profound disconcert with the role of the travelling theorist or artist "who turns up to lecture you all on what a bad time you are having". He turned out to be perfectly correct on the first point. Indeed, many art institutions at that time fulfilled the role of sanctioned protest. But what chance did they have? Should they have kept quiet or openly asked for some kind of fascist intervention into their activities in

order to gain credibility? So although Ratnam was completely right, it didn't make any difference concerning the situation at hand. The second point is more complex and touched the core of Austria's problematic relationship with the term of antiracism. It is a well-known fact, especially in the artworld, that basically all countries are quite enthusiastic about migrant artists, as long as they live somewhere else. In this case they will be regarded as experts of cross-cultural communication, of globalization and international affairs in general. But should they happen to be 'domestic migrants' they will rather be considered as a half-illiterate and retarded bunch of hopeless artists unsuccessfully trying to compete with the indigenous artists. In Austria this attitude led to an interesting art phenomena during the 1990s, namely an increased attention towards artworks concerned with migration, globalization or postcolonial issues, given that these artworks were produced in any place except Austria. Therefore an Austrian art public achieved a quite impressive and purely theoretical knowledge of these issues – as long as they were perceived as an aesthetic phenomena located at a safe distance. Not only was the contemporary exclusion of foreigners from most areas of Austrian society not considered relevant to these debates, but also more specifically their exclusion from the artworld. Apart from that, hardly anybody tackled the long-lasting domination of Austrian emperors over a vast array of South-Eastern European countries as a postcolonial relationship. The history of the Austro-Hungarian Empire is closely connected to present day migration patterns to Austria, where most of the migrant labour force comes from former imperial territories. None of these local ties had been given any attention.

Obviously, this kind of abstracting reception of postcolonial art and theory was very productive in promoting the rapid succession of travelling theorists and artists in Austria who lectured the local art scene about hybridity and postcolonialism. Migrants who would eventually question this type of advanced exclusion practice would be told that unfortunately their artworks did not show a sufficient understanding of contemporary art theory. Had they only understood, that nowadays everybody had a hybrid, flexible and fluid identity, they would certainly not assume such an essentialist position as to criticize their own exclusion from the Austrian artworld. All of these attitudes were

reflected in the various responses to Merali's show. Since the symposium had been cancelled due to the boycott, a panel discussion had been arranged. While Merali was criticizing the obvious exclusion practices towards migrants and people of colour both within the artworld and the opposition movement, most of the discussion was focussed on possible consequences of the boycott for Austrians. I am not even sure, that Merali did understand what it was about, since most of these discussions took place in German. The confusion therefore was considerable. Still I do think that Merali's approach, even though it ended up in complete confusion, was in the long run more productive, than the understandable boycott reactions of his British colleagues. Why is this? Merali did not behave like the travelling theory tourist, but helped to support and articulate the claims of those people who had been affected by Austrian racism and also anti-Semitism all along the way.

During these events one incident passed almost unnoticed. Merali had recontextualized Mozart's Requiem as a dark object of colonial genealogy. He brought the requiem back to Vienna via a long detour – contextualized as a condensation of tourist kitsch and a genealogy of deadly oppression. Lacrimosa, the title of the movement, means in this constellation: dark things which point at tears and crimes, which pitch like acupunctural needles at the geographical, the ideological nods, where the energy of death and pleasure is circulating under the surface. On Feb. 28th, 11 graves were thrown over in the Jewish section of Vienna's Central cemetery, close to Mozart's own grave. Four of the graves belong to people who were murdered in Buchenwald.

According to Saul Friedlaender, kitsch and death mark the aesthetic constellation of anti-Semitism. Of all things, nazism becomes 'the center of an outburst of everything repressed', where regression and pleasure merge. Adorno wrote: 'To read the constellation means to decipher its historical formation. In Austria it actually translates into the genealogy of fascist desires and crimes and their lasting effects.'

More than one and a half years after these events, the government is still in power. The opposition movement has faded away and is almost out of operation. All the heated debates about art, politics and racism have calmed down. Some of the art institutions suffered heavy cut backs in funding. Some didn't. The weekly Thursday demonstrations are still going on. At the moment they have around 120 participants. Vienna is quiet. All is back to 'normal'.

Masquerade as Masculinity: notes on Shaheen Merali's Paradigms Lost

Adrian Rifkin

Paradigms Lost has one of what for me is the defining characteristic of a work of art: it's very hard to describe, as is a complex painting.

Take one example, and the most exalted makes the point best of all: to begin to describe Titian's Sacred and Profane Love as a painting with two allegorical female figures, on the one hand, or as a strangely lit landscape on the other, may produce two results that strain analogy. The difference between the two might be something like the difference between an historical and descriptive iconography and a psychoanalytic reading of a relation between painterly technique and affect. Where and how the two elaborations fold into each other may be a matter only for speculation. But in either scenario the description of the surface, the starting point for the description and values accorded to the ways in which the surface can be recounted will only partially coincide. If the beginning were the light, you might start either with that which bathes the landscape, or that which modulates the figures – these are not identical. Or if you began with the figures, you might note the striking difference of their respectively clothed and nude states, or with the way the landscape meets their outline. In either event the role of each element gets to be more and more complicated. From the outset the relation of light and figure is not an easy one, nor is the entry into their description and the framing and re-framing of it in anyway self-evident. Unless, that is, you pull down the task-bar 'iconography'. Such questions are well enough worked in some art historical studies.

I want to put these considerations in place because Merali's work has all the appearance of an art of immediacy; it would be easy enough to say that his piece recounts the anguish of an Asian man who suffers a racist attack – sweat, fear, anxiety displacement, failure of utopian dreams of the harmless suburb; and that this attack is framed by images of what appears to be a half-secret bureaucracy, documentary scenes from the horrors of political violence in the contemporary world and a homo-erotic ballet performed by two men in jock-straps, all repeated four times against a background of alternately spoken and/or musical soundtracks.

This would be very different from writing that 'this is a film where the camera has no stable viewpoint but

rather takes turns, half turns and fictional movements due to borrowing, insertion and layering...', for example; or 'this is a film where, despite repetition, the expected modes of elision between sequences is never quite what you are expecting...'; or 'this is a film in which the words fear and sweat coincide and echo with images of both the threat of violence and the threat of desire, and where the voice/image relation is inflected and determined by musical rhythms and cutting speeds...'. To multiply, even to exhaust these fragments of description is to refigure immediacy and political urgency themselves not as driving the poetics of the tape but as needing their immersion in procedure as a condition of visibility.

One paradigm to get lost in is the viewer's condition of virtuous attention. Remember too that the lost paradise of Milton's epic was not only the fall of 'man' Eden, but the rebel angels' loss of Heaven. It is they, the 'villains' of the piece, who suffer with an articulate, aesthetic and physical rage here shared by the 'victim'. It is the victim who sees through, as through a lens, the uncertainty of anchoring his rage, the ambivalence of its drive, its investments and its pleasures.

The scene of the 'attack', the rough, used and abused concrete and metal of an old warehouse or factory, the hard light, crumbling, slow moving ventilation that industrially recalls a colonial fan, are all emblems of and materials for an urban nature of our time. They frame, distort and value the figures that move amongst them, fill the emptiness of the dance sequences with the memory of their return, make the habitus for an anxious look between the fades and the returns; the 'victim' is occluded by the 'attackers'' bodies, their kneading fists, and now he looks back at himself beneath them, speeded, fucking rhythm, before, slowly, they dance away, and if he goes through the door it is the dancers who return; implacable in their presence, uncertain, unavailable to each other in their touching, sliding in and out of grasp in counterpoint to the pummelled body; the light foretells a sequence with a shadow; a grained light falling through reeded glass, next about to appear not as the shadow of a filter, but as a screen, a Chinese shadow of a male half-figure in a bowler hat who hangs up a telephone. Then 'extreme', a stencilled, graffitoed word, appears and reappears, the scenes of violence in the wider world...

Cut against equivalent hardnesses of world-wide violence, these spaces generate a politics of resistance; to racism at its immediate and local point of impact and, at the same time, to modern imperialism in its global structures. This a kind of iconography, though it points to more than one phantasm of catastrophe. So, the dance draws us to desire and longing between male bodies; the veiled and silhouetted bureaucrat behind the reeded glass, with his deliberated telephonic gesture, points to a relation between the precisions of power and the anonymity of gender, and the replacement of the telephone is not without a dance-like quality; nor is the dance free from the anomie of a veiled and distracted intimacy in its half light of red and grey, its failing, sliding gestures, its incomplete embraces.

To say all of this is to move beyond the previous propositions, but not far. It is to suggest that even the manifest meaning is a complex one, but to leave it at the level of the manifest, rather than to attend the significance that these ever more complete descriptions seem fated to avoid, and which is perhaps no less than the sum of their elisions. (That said, I have seen a video of a woman dancing in her studio that seems to be exactly that: a woman dancing in her studio. You could add some comments on the music, the measure of her movements, her age, the number of shots, but it remains just that. The simplest outline exhausts the matter – it is a woman dancing in her studio – or so someone told me, perhaps the label on the wall. Maybe the tape had some perfectly blatant reference to the Maenads in old Ovid... but the label made no mention of that at all. Even if I dressed up and danced along with her there would be little in the way or empathy, sympathy or even alienation. The distance is already counter-aesthetic).

One way of approaching Merali's tape is by getting dressed to watch it – that is to set up a friction between the image and the viewer, or a space for recognition. Another, as I have tried to do, is to take it frame by frame and sound by sound and to see if it can be broken down into discrete sèmes that sustain any consistency across their repetitions. In effect these two procedures have something in common as they enable us to focus on how we notice things in the work, as a kind of viewer. I can't get dressed like the 'victim' himself, not just

because it's not my style, but because you don't need Fanon to tell you that I can't black up. Yet in the very last shot of his tape, a borrowed news-sequence, we see a figure in a blouson hurrying past some street atrocity, a man who looks rather like him. In the repeated sequence, when he turns towards the metal door — the metal door that holds him to his being beaten up, or that admits him to the fantasy that lies beyond or beside the attack, he looks like this. Here, in the clip, the man has only the colour of a silhouette, the outline given by a jacket and pants all over the post-colonial world. The figure's only identity is that of the passer by, half-curious, half-indifferent and faceless, and if he resembles the 'victim', then the artist has sidestepped the meanings of his film. If, and I hesitate, if there is such a random gesture of identification with that figure, then it doubles the narcissism of this self-regarding work, mapping the artist once more and conclusively into the constitutive materials of his vision both as its over identified centre and as its furtive margin. Between these positions the film spins out its beauty…

I could get dressed like that, in the cheap, universal rags of the world-wide rag trade, and try to pass by the tape as it rolls on my TV screen. But to get across the histories of my own identity, I would have an awful lot of stuff to wear on my sleeve, probably enough bits and pieces to distract from the work of art itself; so my sleeve will stay well out of this discussion. The chances are that anyway, on any day of the week, I might be dressed like some of the thugs who assault him in his film. In a blouson, jeans or combats, army boots, a shaved head — in fact they have quite nice hair, which jars with the proper fantasy of violence, with my own fantasy of confounding self and other. But I am more a clone of his 'attackers' than of the 'victim'. So, to identify Merali's talk of masculinity I will dress like this to watch him. If this seems like an aggression, I refer the nervous reader to a very good, and politically perfect, German website named something like schwulen skinheads gegen fascismus und razismus for a quick fix to your anxiety; although this may anyway be provoked not so much by the political monstrosity of my proposal as by the well-known but burdensome matter of the pluri-conventionality of such signs of dress and style and masculine masquerade. Left-wing intellectuals and skinheads dress alike and sometimes seek each other out… And

then it would be clear that, while I might fail – and I insist on the word might – to empathize with those guys, nonetheless I like their spaces very much. Indeed I've been in them, written about them, the spaces of conjunctural and marginal sexual encounter – of a homo-masculinity that plays with the tropes of exclusion and abjection, turns them around and against the political economy, the moralism and the hetero-normativity that produces them, and in doing so risks accepting intolerable things, or the desire for intolerable objects.

The video makes this available: it is attractive not least because of its subtle and layered appeal to the inauthentic. There is nothing in it to say anything other than that this scenario is being acted out. Each gesture, movement, configuration of sound and image, the formulation of each set of images reminds us that this is not a matter of documentary; that it is not a document. Nor is it fiction. What lies between documentary and fiction? Certainly this is not a historical drama played out by actors on the basis of real-life characters, though many of the actions have been seen, or hidden from sight, time and time again on our streets. What else lies between the two, what other form of narrative confounds the possible with the actual at the borderline of poetry? One answer is the daydream... The daydream needs to be set up and it needs to flow; to work it requires coherence and absurdity, conviction and hyperbole, close contact with the preconscious of the dreamer... all reasons why Freud so liked the daydream. Merali's tape is attractive like a daydream that threads and weaves between the thinkable and the inadmissible. Politically it's a disaster – even a perfectly correct disaster... Everything about it is set up for pleasure, a rhythm for the sociability of bodies, of dance and walking, of beating and fucking, of staccato pumelling and slowed-down flight, guns against graffiti, unfocussed waiting and excessive attention; the daydream that tracks to and fro and back across its own materials, its medium, in the hope of keeping them in place, repeating them but never, from moment to moment, with the same effect.

And therein lies the fear, the sweat, the smell, in the pleasure of the daydream, the signs can never settle. And to rouse yourself from it, to walk back into the fully waking world, is to admit their frail coherence.

Tales
from
the
Dark
Side:
Double
Agency

Jean
Fisher

To educate man to be actional, preserving in
all his relations his respect for the basic
values that constitute a human world, is the
prime task of him who, having taken thought,
prepares to act.
Frantz Fanon [1]

Shaheen Merali is a man of many parts: artist,
educator, writer, curator and archivist. To be an
animateur is an enormous responsibility for an artist
to take on alongside the pressures of his own
creative work. And yet it was a role assumed by many
young black British artists who emerged in the early
1980s.[2] But why was it necessary for them to create
their own platforms for exhibition and debate?

The institution of art, like most other areas of
social and cultural expertise, has always operated
through a system of inclusion and exclusion which,
following his studies on early modernism Pierre
Bourdieu designated a 'restricted field of cultural
production.' [3] Functioning at a largely unconscious
level, Bourdieu's field of culture is an insiderist club
of agents — dealers, collectors, curators,
museologists, art critics and historians — who
'consecrate,' determine and give economic and
intellectual value to the productions of other
agents: the artists. Whilst, according to Bourdieu,
this field has built into it the capacity to shift value
enabling, for instance, avant-gardist challenges to
the language of art posed by successive generations
of producers, it nonetheless is governed by a set of
internal and exclusive rules understood by all aspiring
participants. If, however, this configuration of power
and privilege were constructed and controlled to
promote a particular, ideal national subject,[4] then
what were your chances of being accepted as a
participant if, by dint of gender, sexual preference,
race, ethnicity, disability or class your perception
and representation of reality did not endorse its
values? The question inevitably arises, how can the
boundaries of what is seemingly a closed, self-
serving and self-perpetuating system be breached
or reconfigured to admit other sets of values?

The artworld is, of course, only one instance of a
widespread institutional violence that discriminates
against the rights of certain citizens to participate
in cultural and political life as creative and
responsible social actors. By the 1980s it was
becoming clear that the relations of power and

privilege organized by a hegemonic 'white' elite were no longer sustainable in a society that now visibly and structurally comprised heterogeneous ethnic populations. For second generation diasporic actors, British-born and educated, the passive assimilation but implicit sense of dislocation endured by their parents in a new country reluctant to recognize them as anything but 'outsiders' was not a tenable position, presenting a challenge to prevailing assumptions of what constituted British identity and belonging. As Fanon insists, for any discriminated 'minority' the task of repositioning itself in society in terms that restore a sense of human value demands agency; or, as Michel de Certeau puts it, claiming the power of speech: 'the capture of speech clearly has the form of a refusal. It is a protestation. We shall see that its fragility is due to its expression as contestation, to its testimony as negation. Therein, perhaps, lies its greatness. But in reality, it consists in stating, "I am not a thing." Violence is the gesture that rejects all identification: "I exist."'[5] And it is around the consequences of this violence that much of Merali's work articulates.

One might imagine that the boundaries of a closed system like the art field could be transgressed by pressure either from within or without: either the field is weakened internally by its own stagnancy or degeneracy, or events outside it compel reform. In fact, by the time Merali emerged from art school at the beginning of the 1980s both effects had been set in motion. From 'inside' the academy, diasporic postcolonial theory and Indian subaltern studies had produced a new generation of Black Atlantic and Asian intellectuals who questioned modernity's legacy of Enlightenment values and their implication in the colonial enterprise. From the 'outside,' following a series of urban race riots expressing a frustration at poor housing, employment, education and physical abuse, the government was forced to respond to the economic, political and cultural disadvantage of its immigrant populations with some financial support for cultural development, which for a short time provided funding for black-led organizations, 'community' arts and local artists' residencies. Although the latter, controlled largely by local authority budgets and initiatives, tended to emphasize spurious identification between artist and community on ethnic grounds, they initially provided black artists like Merali with both a modest income and an actional field in which a wider political dimension of art than

that provided by the narcissistic concerns of the mainstream art world could be conceptualized and tested in practice. It was the ground from which Merali was able to develop more pluralised tools of agency, translating experiences and ideas across different cultural spaces. In one such workshop, in the early 1990s in South Camden Community School with mainly Bangladeshi children, Merali combined teaching photographic skills with ideas about portraiture that encouraged them to see how images of self were mediated by the camera. This engagement in turn was developed into an installation, Confrontations, 1993,[6] which explored the disjunctions between the sense of subjective value constructed through self-representation and the depersonalising effects of exoticized images that circulate as postcards or greeting cards, and through which racism is reconfigured and domesticated under the seemingly more benign terms of popular humour or cartoons of ethnicity.

By the turn of the 1990s, the art institutions had begun their flirtation with work involved in 'cultural identity and difference,' widened the exhibition possibilities for black and Asian artists, but at the price of commodifying difference. It was a form of 'containment,' maintaining the separation of ethnicised artists from white mainstream art through what Sarat Maharaj has called the 'management of difference,' [7] effectively foreclosing any meaningful dialogue between them. There is no doubt that critical and curatorial focus on 'anthropological' readings of the artist — biography and sociocultural background — was at the expense of serious debate on the aesthetic experience of the work itself and its formal relations to a wider context of artistic practices. Increased visibility for black practitioners throughout all cultural spheres therefore did not signal the end of racism. Thus Kobena Mercer, speaking specifically in reference to African America, but with some resonance in Britain, noted that '"hyperblackness" in the media and entertainment industries serves not to critique social injustice, but to cover over and conceal increasingly sharp inequalities.' [8]

These shifts in the political and institutional landscape demanded a re-conceptualizing of artistic strategies and a more subtle form of identity politics than what Gayatri Spivak had called 'strategic essentialism' — the positing of a transcendent black

subject or experience in order to interrogate the relations of power and inequities that circumscribed his and her cultural positioning. Although Merali has consistently worked within a politics of inequity, his work in fact has never subscribed to essentialism, but rather has always tended towards an examination of the ambivalence of intersubjective or intercultural relations. It is a situation best described by Stuart Hall who, as early as 1988, had identified a redoubling and repositioning of black British cultural strategies from what he called a struggle over the relations of representation to a politics of representation itself, from a concern with the marginality of the black experience, its simplification and stereotypical character, to a recognition of the 'extraordinary diversity of subjective positions, social experiences and cultural identities' that compose black as a 'politically, historically and culturally constructed category' inscribed with racism's ambivalent play of identification and desire. This called for a new concept of difference, which was not transcendental but 'positional, conditional and conjunctural.' [9]

Racism's 'ambivalent play of identification and desire' is indeed one of the themes that constantly traverses Merali's work, a turbulent, unfinished dialogue about what constitutes national belonging and identity in an urban Britain where the 'other' is no longer 'over there' at some safely indeterminable distance, but one's proximate neighbour. And if proximity poses a threat it is not because of difference as such, but because the self is forced to confront, in the intensity of its violence, the other's desire. It was precisely this denial of the right to say 'I exist,' the recognition of selfhood, which Fanon placed at the heart of the subtle psychopathological manoeuvres that disharmonize and dehumanize the black self under colonial repression. Speaking of this psychic alienation, Fanon insisted that 'If there is an inferiority complex, it is the outcome of a double process: primarily economic; subsequently the "internalization — or, better, the epidermalization — of this inferiority;" or again, the feeling not even of inferiority but of "nonexistence."' [10] 'As soon as I desire I am asking to be considered... He who is reluctant to recognize me opposes me. In a savage struggle I am willing to accept convulsions of death, invincible dissolution, but also the possibility of the impossible.' [11]

The psychosocial dynamic of this confrontation is central to Merali's work; it is behind its explorations of the many faces of violence, from the banality of physical aggression, to the institutional enforcement of alien values, languages and customs, to the exploitation of native labour and the violation of others' spaces. But Fanon's willingness to take on the 'possibility of the impossible' is also what drives Merali to activate the confrontation on multiple fronts, from challenging the art world's 'restricted field of cultural production' from within, to building post-national alliances with artists tangential to the mainstream, thereby traversed nationalistic, geographical and cultural borders. With respect to the latter, Merali was instrumental in initiating British black artists' involvement in the Bienal de La Habana (the only international event to which they had access in the 1990s), and was a co-founder with Allan de Souza of Panchayat Arts Educational Resource Unit, an archive initially concerned with documenting and exhibiting the work of contemporary South Asian artists based both in the Subcontinent and Britain. [12]

Much of the artistic language Merali employs derives from attentiveness to the conditions of disempowerment: it functions as a point of articulation where the experience of personal trauma recognizes the need to give voice to a wider suffering. Among the intellectual aims that one comes to identify with his multivalent practice is to de-ideologize and re-politicize the assumptions of ethnicity that lead to reductive and even defensive expressions of cultural identity and ossifying stereotypes; to explore the complex, often generational, inner conflicts of adaptation and resistance, belonging and exile, memory and hope inscribed in the multiple cultural identifications that constitute the diasporic experience; to recuperate a shared history of colonialism and its consequences elided by Western imperialist history; and to identify situations where economic and political injustice persists in those communities positioned at the interior and exterior margins of the affluent world.

Merali however creates spaces of agency that refuse the position of marginality. He may concur with bell hooks' anti-mythic version of black marginality: that whilst it is typically associated with deprivation, misery and impotence by the advocates of victimology, it can also be seen more productively as

an intellectual position of agency, a 'site of radical possibility,' a position and place of resistance and remembrance where one can 'imagine alternative worlds' and nurture a 'counter language.' [13] At the same time to acquire subjective agency, to construct oneself as a subject, one must grasp the power to act and control elements of one's own world, to connect with power — with aesthetic and social structures capable of producing cultural meaning and an effective political voice. That is, as Merali recognizes, one cannot operate effectively as an agent of change only in the margins, but must grasp opportunities in the centres of power themselves. A distinction must therefore be made between collective affiliation and the demands of individual artistic endeavour and how they intersect; the artist might refer to a collective trauma but his work speaks from an individual position. If there is here recognition of the need for renewed strategies of engagement between artist and community, these cannot be on the paternalistic terms of institutionally directed educational ethnic arts programmes, nor can they be restricted to the elite site of the conventional gallery. Merali hence has actively sought out temporary local spaces for workshops and exhibitions, and evolved flexible artistic methodologies where elements of a work can be reassembled and recombined in configurations appropriate to each new site.

Thus on a number of levels Merali's diverse tactics function as a pressure on cultural hegemony from both 'within' and 'without.' Or better, since no boundary is impregnable, he locates moments or sites of porosity, insinuating through a range of culturally mobile, transgressive and opportunistic tactics that, in de Certeau's words, 'steal our knowledge from behind' and 'reuse cultural space' [14] — in short, a form of guerrilla warfare. Traversing multiple and contradictory identificatory worlds, both communitarian and institutional, as artist and curator, educator and writer, archivist and collector of politically charged memorabilia, Merali is the quintessential double agent. The consequence of this 'theft' of knowledge and 'reuse' of cultural space is that the language of dominance undergoes a crisis of meaning, or what Deleuze and Guattari call a relative 'deterritorialisation' or 'minoritisation,' characterized as connection of the individual to a political immediacy and the formation of new collective assemblages where expression or enunciation precedes any

predetermined meaning of its contents. [15] It is, as the authors point out, what a minority does with a major language, examples of which are plentiful within the vernacular skeins of British popular culture.

The Artist as Storyteller

> There are thousands of stories to tell, a vast untold human experience. Like stolen treasures buried in the vaults of celebrated museums they remain silenced witnesses to the passage of time. Their accounts, their unbolting of the closed doors of documented history throws open the paths for exploration, re-discovery and a re-charting of time.
> Shaheen Merali [16]

Merali's preferred artistic form throughout the 1990s was the mixed media installation: an expressive 'collective assemblage' from whose multiple contents the viewer built his or her own narratives. Whilst the installation has been criticized as the lingua franca of international art and hence a sign of aesthetic homogenisation, it nevertheless has a number of advantages which articulate a different economy of exchange to that of more traditional media. Firstly, as a relatively new form of presentation 'belonging' to no one in particular, it by-passes the tiresome myth that Europe had 'authentic' proprietorship over modernism; secondly, deriving from architectural or historical readings of 'site specificity,' it provides a universally understood matrix into which less familiar 'local' or vernacular contents, diverse and divergent spatio-temporalities can be woven; and thirdly, it is a performative mode of address that empowers viewer participation in the construction of meaning. As we shall see, it enables the space for Merali as artist to function rather like a storyteller: it provides a structure and context where private memory and public news, local imagery and popular icons, or otherwise, a delirious excess of rational and non-rationalist knowledge systems like astrology and the recycled discards of Western culture may be combined in open-ended dialogues. In this way, as Walter Benjamin said of storytelling, the work possesses 'amplitude' that mere information lacks. [17]

In 1995 Merali produced Paradigms Lost, Parts I and II, a video installation and single channel work showing a man backed up against a closed door and menaced by a group of thugs. The image is

accompanied by a music soundtrack — a mix of punk/reggae, drum n' bass and ambience, reminding us of the extent to which black music has penetrated culture at large; and a voiceover narration (a subject describing his experience of coming to the UK and being assaulted), but from whose rapid delivery only the occasional word is audible. There is ambivalence in the way the bodies are choreographed — the uncomfortable intimacy of a homoerotic dance or physical assault, echoing the dual aggression and attraction that inscribes our imaginary relations with the 'other' in the psychoanalytic schema. The piece speaks ostensibly about wanton racist attacks on Asian peoples, specifically referring to the beatings of both Muktar Ahmed in Tower Hamlets in 1995 and Merali himself, but the accompanying footage of the Gulf War widens the issue to encompass the West's problematic historical orientalist relations with Islam. Paradigms Lost was commissioned by The Travelling Gallery, 1995, [18] a bus converted into a gallery that toured the North of England and Scotland like the old mobile libraries that service remote rural areas; or again, like temporary market stalls or mobile van-shops, phone cab services or salsa classes: all itinerant occupations that first-generation immigrants invent in the absence of any rootedness in the 'host' economy. In Merali's installation, one length of the interior was taken up by a 10 x 4 foot Duratran light-box of an image of a bookcase displaying titles about foreign travel and art from non-Western cultures. This faced a bookcase of real books whose spines were turned to the wall so that their titles could not be read; while the end wall carried a shrine-like display of the video monitor together with photographs of Merali after his assault. Embedded in the virtual bookcase were projected images of Muktar Ahmed composed in the form of a swastika, prompting associations between the repression of knowledge and truth represented by the book-burning and Jewish persecution of Kristalnacht, or even Truffaut's dystopic futuristic vision in Fahrenheit 451, and the touristic fantasy that demands the exoticised other be 'knowable' while remaining at an 'uncontaminable' distance.

On one level, the work speaks of the non-transmissibility of traumatic experience. We become uncomfortably aware of our limited ability to hear the narrator's story. But this opens onto the question of the complicity of 'civilised' nations in acts of barbarism. It is not that the narrator cannot speak

— the 'stuttering' of language here does not derive from his inarticulacy. [19] Rather it is that, in the transmission between utterance and reception, something disables our capacity to understand, just as the impenetrable books prevent us from reading. In like manner, we are made conscious of our inertia as witnesses to barbarous acts against others whose experiences, like the nomadic nature of the bus itself, we identify as part and not part of British postcolonial contemporary life, where 'there' is also ambiguously 'here,' in a shared but often unacknowledged history. Finally, then, the work opens onto a debate about our ethical responsibility to the other: about a complicity of silence encircling the socially manipulated economy of desire for the imaginary other that simultaneously denies another's reality as a human being.

Merali has frequently returned to this theme, most notably in an earlier series of three interconnected installations of 1991, It Pays to Buy Good Tea, [20] Fire, Theft and Acts of God [21] and In Health and Sickness, [22] that circulate around the West's indifference to human rights violations with respect to the Tamil struggle in Sri Lanka. [23] All three works are concerned in some way with the violence against the body, recycling painful images of atrocities. In In Health and Sickness, 1991, images of wounded and dying Tamils were projected across a pair of hospital beds, complete with drip feeds and the decaying remains of breakfast trays, and draped with mosquito netting, the barrier against disease, but also under colonial occupation a sign of the distinction between colonial and native. The beds, abandoned because AIDS sufferers had slept on them, also referred to a story in which a hospital was prepared for US soldiers in the Gulf War to which Tamil wounded were refused admission for treatment. Fire, Theft and Acts of God, included a series of silk kurta pyjamas, the traditional men's garment in the Indian Subcontinent, printed with images of atrocities or of fire, water and earth, alluding to the violence of Fanon's 'epidermalization' of the other and the corresponding mutilation of colonized space.

Part of It Pays to Buy Good Tea [24] set the terms of the enquiry: four slides each bear captions from French TV news reports with English subtitles: 'Sinhalese Took Revenge' — 'Many Tamils Fled North' — 'Curfew Imposed in Capital' — 'Tourists warned "stay away".' Projected in differing sequences, the viewer

was confronted with an ambiguous narrative: What was the order of events? From whose position was the story being told? Whom was it addressing? What position was one encouraged to take in relation to it? More crucially, perhaps, what distortions of the 'truth' had occurred in the processes of translation from the distant moment of the eyewitness account to its arrival on our TV screens? And by analogy, what distortions of meaning had occurred in the interval between the tea's site of production and its site of consumption?

It Pays to Buy Good Tea was dominated by a giant teacup and teapot constructed from tea bags and set against projected images of refugees. The sword of a large, free-standing cut-out of the Lion of Sri Lanka — emblem of the national flag as well as Lyons tea — 'sliced' through a stack of tea chests 'exposing' photographs of mutilated bodies on their inner surfaces. Tea and sympathy, the British panacea of comfort in distress, is not the order of the day here. As has so often happened in the imperialist scenario, a combination of exploitation of local resources, imposition of a single-crop economy and imported labour produces a beggaring, unstable and non-sustainable situation. [25] Thus the work alludes to a socio-economic reality against which the pastoral image of the sari-ed woman picking tea leaves of our TV ads is sheer fantasy.

Merali's juxtaposition of cheap Western commodities with the very different significations they hold in their 'Third World' sites of production opens onto a wide vista of global exploitation where again and again Western concepts of emancipation and progress produce an ever-increasing violation of the others' space and the dehumanisation and immiseration of the other's body to slave labour; and where, as Merali's heavy plaster casts of life jackets that form part of Silent Seekers, 1994, [26] ironically comment, 'salvation' becomes the rhetorical (if not actual) mission of those who created the problems in the first instance.

For Merali, racist exploitation becomes domesticated not only through the commodity but also the tourist industry, a theme explored in Going Native, 1993, [27] and located in the ex-Portuguese colony of Goa. The viewer was invited to relax in white canvas deckchairs in a 'video lounge' watching a projection of Franciscan monks — among the earliest tourist-invaders — walking along an idyllic Goan beach, while

images of hippy tourists played over the deckchairs. A mélange of Indian popular songs from the 1960s and 'Lacrimosa' from Mozart's Requiem wafted from the speakers while a further projection zoomed in and out of the product logo of a Coke dispenser, resting on the fragment OK. Beneath the Edenic promise of the travel brochure image however all is not OK, for it disguises one of the industry's biggest growth sectors, sex tourism, a violation of the native body directly linked to economic impoverishment that can be traced back to Goa's first Portuguese colonial authorities. Hito Stereyl says of this work: 'Lacrimosa, the title of the movement, means in this constellation: dark things which point at tears and crimes. Which pitch like acupunctural needles at the geographical, the ideological nodes, where the energy of death and pleasure is circulating under the surface.' [28]

On another level racism becomes internalised and domesticated in the form of the seemingly innocuous tourist souvenir or cabinet figurine. Over the years Merali has assembled a large collection of memorabilia, drawn largely from mass consumer culture and the kitsch end of the luxury goods market, depicting the racialised other as a caricatured, miniaturised or grotesque body whose circulation — most notoriously as the Robertson jam 'gollywog' — was at least for a time banned in the UK. That a black artist should collect and reuse negative racial stereotypes might be seen as quite controversial to an earlier generation that fought for 'positive' cultural images. On one level this may be seen as 'making safe' the deep cultural trauma produced by images that sustain racist myths and displace historical reality; [29] but on an artistic level, Merali is clearly concerned with excavating and reclaiming this 'hidden' and 'discarded' archive in order to re-present its racist signs in contexts — or 'constellations,' as the artist proposes — that might expose the psychosexual dynamics behind their original production and the desire to collect them.

One such constellation is presented in DigNative, 1999, a faux-museum installation that directly relates to Merali's concerns with the archive and the collection as spaces ideologically inscribed with relations of power and privilege: the set of values that nominates certain artefacts as 'precious' and constructs a whole curatorial support system of research, documentation, restoration, conservation, collection

and display. Against this practice is the ethnographic museum specializing in 'curiosities' or 'ethnic artefacts,' which was notorious historically for decontextualising its exhibits and suspending them in the timeless space of its own ideological boundaries.

Part of the installation comprised a set of vitrines whose 'precious' and 'fragile' contents were selected from Merali's collection of black memorabilia, near-buried or in some way trapped in various polystyrene packing materials. In one vitrine the objects were almost consumed by a froth of polystyrene 'bubbles,' which the artist says was inspired by the few black arms and legs disappearing in the turbulent foreground sea of J.M.W. Turner's painting Slaver throwing overboard the dead and dying – Typh[o]on coming on, 1840. [30]

Our ability to see the interior of one of the vitrines however was severely limited by the coating of white lanolin cream that covered its exterior surfaces, and any attempt to wipe it away merely smeared it further. Hence, as in Paradigms Lost amongst other works, Merali is always at pains to make us aware of the fallacy of Western assumptions: that the ethnic other is transparent to the gaze, knowable by Western criteria of value, producing a frustration through which, nevertheless, the sensuous space of the object is transformed into a space of thought. In part this provocation is initiated through little strategies that encourage active intervention on the part of the viewer. This is perhaps most obviously demonstrated in U Blow Me Away, 2001, an installation in the window gallery of Central Saint Martins School of Art that faces onto the very public Charing Cross Road. Inside the windows Merali displayed the image of a minstrel figure, standing and upside down, rendered in Hancock's Universal marker on black photographic backdrop paper. A fan animated a negrophilic toy balanced on polystyrene bubbles and fluttering red strings, catching the passer-by's attention but mimicking the flickering movement of the filmic cartoon figure, which historically has been one of the more subtle ways by which racism enters the popular unconscious. The street surface of the window was painted in whitewash and in no time at all became covered with a plethora of graffiti, some of which, not unexpectedly, was racist in tone.

A similar strategy was employed for Dark Matters, 2000, which coincided with the rise to power of the

fascist Freedom Party in Vienna. [31] The structural model here was the 'work in progress' of the artist's studio, displaying on work tables some of Merali's archival source materials and recycled elements of earlier works — the printed kurtas, plastic bags containing photocopies of documents and banners relating to 20 years of black political struggle, together with a large painting on a separately constructed wall of a monstrous but fragmented Darth Vader. This figure from popular cinema resonates across a cluster of significations: he is the black 'bad father,' the powerful black role model whose fall from grace always attracts disproportionate public censorship; or in the context of Austria, the dictator who engineers social divisiveness. In response to the Viennese political situation, Merali added a day-by-day accumulation of street debris from leftwing flyers to fascist posters about the economic effects of immigrants.

In the tourist souvenir or figurine, black caricature intersects with the tradition of the miniature, which is bound to the subject's desire to reduce the overwhelming scale of the exterior world to the controllable dimensions of self, and inevitably opens onto a play of fantasy. For Susan Stewart, 'The narcissistic, even onanistic, view presented by the miniature, its abstraction of the mirror into microcosm, presents the desiring subject with an illusion of mastery, of time into space and heterogeneity into order.' [32] As Merali himself has said, 'One has to remember that, although most souvenirs are attached to locations and experiences that are not for sale, these souvenirs are attached to the concept of Empire and its ethni(cities), dictated by economic needs and subject to consumer culture.' [33]

In Stewart's account, the miniature 'tends toward tableau not narrative, toward silence and spatial boundaries rather than toward expository closure... Hence the nostalgic desire to present...the cultural other within a timeless and uncontaminable miniature form.' [34] In this sense DigNative presents the quintessential space of the miniature: the protected and sterilised world of the glass vitrine. But if the miniature tends towards the timelessness of the tableau, Merali also reclaims it back into narratives of complicity between museology and the representations and display of racialised difference. The represented body of the 'other' is always in some sense 'monstrous', excessive in its display of either

overdetermined body parts or their lack. 'Monstrous' derives from the Latin word meaning 'to show,' and what the monstrous other demonstrates is difference: the discriminating distance that holds the other in the sphere of the self-same while maintaining the precarious boundaries that must separate it from the self. The most notorious real-life story of the other made monstrous is that of Saartje Bartmann (the 'Hottentot Venus'), who, enslaved in South Africa in the late 1700s, was put on public display in Europe, became the subject of scientific investigations and then embalmed, all to demonstrate that her large buttocks and genitalia were 'proof' of the aberrant sexuality of the African woman.

In It's Cheap to Run, 2000, Merali provocatively takes on the issue of the monstrous other not by direct reference to the other's body but to its representation while reversing the domesticated 'security' of the miniature. The work is a gigantic white, inflatable, grinning — or grimacing — sitting 'gollywog' designed to fill and overwhelm the exhibiting space such that the viewer is compelled physically to confront its scale, the texture of its white 'skin,' and the ambivalent sensation of benign humour and malignant terror associated with fairground grotesqueries. Through these reversals the work brings to the surface the complex psychological dynamics of fear and fascination, loathing and sexual desire that inscribe the European image of the black other. The 'gollywog' with his servant's uniform — alongside a host of other similar domestic commodity logos like the US's 'Aunt Jemima' — connects directly to the slave economy and the image of the desirable but compliant 'house nigger' who 'knows his place' of servitude and dependency; as well as to 'blackface' minstrelry, or — recalling Bartmann — the late Victorian fashion for the bustle, both of which can be seen as cultural signs that above all serve to domesticate and disguise the ambivalent desire of the white self for the exotic other. This monstrous blanched figure, inflated through the 'anus,' is also a seriocomic allusion to sexual inflatables that conventionally take the form of a white woman, and where, in fact, masturbatory fantasy dispenses with the woman altogether. In other words, the phantasm displaces the real.

Merali takes this particular provocation one step further in Colored Folks, 2001, a joint performance with Oreet Ashery. [35] The premise was to play out a

fantasy of assuming an image of otherness that would also challenge the audience to confront their own desires and identifications. Thus, as Merali progressively transformed into a convincingly delectable white woman, Ashery became a black guy somewhat in the style of Spike Lee. There is a resonance of the pantomime mask poking above the shroud-like hairdressing gowns — effects produced by 'heavy make-up and a cheap wig,' as Merali laconically comments in the video. But the transformations are convincing enough to suspend disbelief whilst simultaneously producing the anxiety of a blurring of boundaries: it is here that we encounter the essence of the 'monstrous' image whose exaggerated difference is erected precisely to defend the integrity of the self. At the end of the performance Merali and Ashery stood in the narrow exit so that the audience had to make a conscious choice as to which ambiguous figure they faced as they sidled out, a decision that presented some with considerable discomfort. [36]

There is of course a history of artists' fascination with alternative identities — Duchamp's Rrose Sélavy; or Adrian Piper's Mythic Being as an experiment in experiencing what it was like to be a black man on the streets of New York. Or Michael Jackson's 'becoming white' and the play on sexual ambiguity that he shares with other stars of music culture. Or what Maharaj calls 'xenophilia': [37] play-acting the appearance and lifestyle of exoticized others as presented by Lisl Ponger in her ethnographic photo-essay on Viennese fantasies, Xenografische Ansichten, 1995. Colored Folks, however, is less concerned with sociological issues than with psychic processes — the deeply ambivalent desire of and for the other that renders the socially constructed binaristic categories of sexuality, race and gender always precarious. And yet despite its seemingly humorous gaming with image Colored Folks has to be seen more properly as a play on an itinerant, contingent and conditional mode of contemporary existence. Underpinning this is serious philosophical reflection that challenges the old Cartesian concept of a unified subjectivity or identity in which mind is privileged over body, and effects a shift from the concept of Being to a delirious Deleuzean notion of 'becoming-other.'

In a moment towards the completion of his transformation, Merali's voice announces in the video, 'Now I don't want to control who I am — what I might

become.' Articulated here is a suggestion that the performance effected more than the temporary switch in the categories of race and gender. Rather, there is a sense of relinquishing the culturally fixed boundaries of subjectivity — the 'who I am' — and a release of desire into a movement of becoming that is not attached to an already fantasized and impossible object, but has an uncertain outcome. For Deleuze and Guattari, systematic and hierarchical social practices mask and disable the capacity of humans to develop transformative processes: to make multiple or 'rhizomatic' linkages, with differing speeds and intensities between heterogeneous systems and subjectivities, both animate and inanimate. Most provocatively, however, they propose that this movement is initiated by desire understood not as the social and Oedipalized effect of lack for which the fantasy is its fulfilment, but as sheer vitality concerned only with the pulsion of its own doing, performing. [38] Whatever reservations one might have about this proposition it has a certain value for beginning to reconsider the relationship of black artists to agency and what Merali seems to move towards in Colored Folks. For if desire is not inherently based in lack, nor in a phantasmatic notion of plenitude or fully-constituted subjectivity, but in an affirmative movement of becoming, then it is in Fanon's terrain of the 'possibility of the impossible,' of grasping the multiple potential of one's own desire disengaged from its entrapment by society; as Fanon also said, 'I am my own foundation.' [39]

What is unclear in this account of desire is an ethical dimension, except insofar as becoming-other establishes non-hierarchical connections with other vectors of energy — and to approach this problematic we cannot as yet completely let go of Lacanian psychoanalysis. If we return to Colored Folks, we see that it alludes to the way the Western binary, identity and difference, masks a deeper problematic. As Peter Mason points out, identity (or sameness) and difference are measurable on a scale of visual signs from absolutely the same to absolutely different. [40] Discrimination is at their core. Otherness however is not measurable in this way. If we go back to Lacan's formula that the other (or more accurately, the desire of the other) is constitutive of the self, then the other is always and already internalized in it — I is an Other, as Rimbaud famously said. This being so, there can be no self that is not also other to itself, no transcendent Being. What is

at stake therefore is not respect for difference as such but respect for life, whatever the differences. It is in this sense that 'identification' and 'becoming-other' as the flow of energies to and from entities begin to open a path to a more ethical understanding of intersubjective relations than the identity/difference binary.

The experience of becoming, of making hitherto un-thought linkages, is an attribute of any art that strives for a transformation in the viewer's positioning, insofar as it encourages a momentary loss of subjective coherence, a confrontation with not-knownness out of which new propositions about knowledge might emerge. Merali's practice as an animateur is nothing if not rhizomatic, as is also his own art practice. It is a practice that confirms Hall's assertion of the 'extraordinary diversity of subjective positions, social experiences and cultural identities' that compose black as a politically, historically and culturally constructed category. The antithesis of minimalism's reduction to the simple with its underlying implication of 'purity,' of form uncontaminated by the messy narratives of life's experiences, it is a celebration of complexity. Assemblage and accumulation: invention as inventory, provisional and temporal, always transmutable into new combinations and connections. It originates in a curiosity about life that embraces a plurality of cultural spaces, the historical and the contemporary, high tech and low tech, popular culture and high art. Indeed, Merali has described his work as 'black' pop art, intrinsically 'postmodern' in its intertextual interrogation of cultural myths and artifices. And like much of Merali's visual and aural source material, black popular and vernacular expression itself with its widespread influence on British cultural life, is also an art of 'making minor' the dominant language, shifting its terms of reference. But it is in this proliferation and excess of means and narratives that we come to appreciate how intimately our lives are linked, and how necessary it is to re-configure the ethics of our relations with the world.

Footnotes

1. Frantz Fanon, Black Skin, White Masks, trans. Charles Lam Markmann, London and Sydney: Pluto Press, 1986, p 222.

2. In the early 1980s in Britain 'black' became a term uniting all cultural producers with a background of colonial and racist oppression irrespective of their ethnic backgrounds. That is, unlike US hyphenated ethnicities or their term 'people of color,' based on racial or ethnic typologies, 'black' designated a political affiliation.

3. This brief commentary is a précis of just a few of the points made in Pierre Bourdieu, The Field of Cultural Production: Essays on Art and Literature, edited and introduced by Randal Johnson, Cambridge: Polity Press, 1993.

4. National identity is a relatively recent construction coterminous in early 19th century Europe with the rise of bourgeois power and the nation-state. It depends on myths of shared history, customs and aspirations (national 'purity') reinforced and promoted through media, public spectacle and emblems. In art it is promoted through public collections and international exhibitions as national heritage, which until the feminist debates of the 1970s, were represented almost entirely by white male artists.

5. Michel de Certeau, The Capture of Speech and Other Political Writings, trans. Tom Conley, Minneapolis and London: Minnesota University Press, 1997, p 12.

6. Exhibited in the Walsall Gallery and Museum.

7. Sarat Maharaj, 'Dislocutions: Interim Entries for a dictionnaire élementaire on Cultural Translation,' in Jean Fisher, [ed], Reverberations: Tactics of Resistance, Forms of Agency in Trans/cultural Practices, Maastricht: Jan van Eyck Editions, 2000, p 34.

8. Kobena Mercer, 'Ethnicity and Internationality,' in Third Text, no. 49, Winter 1999-2000, pp 51 – 62.

9. Stuart Hall, 'New Ethnicities,' [1988], in James Donald and Ali Rattansi, [eds], 'Race,' Culture and Difference, London: Sage Publications in association with the Open University, 1992, pp 252 – 259.

10. Fanon, op cit, pp 13, 139.

11. Ibid, p 218.

12. Panchayat is now housed in the University of Westminster. Their most notable exhibitions include, Crossing Black Waters, travelling to the City Gallery Leicester, Oldham Art Gallery and Bradford's Cartwright Hall, 1992; and unbound geographies/FUSED HISTORIES, Lethaby Gallery, Central Saint Martin's School of Art and Design, London, in collaboration with Zenmix 2000, British/Canadian Xchange programme at A Space, Toronto, 1998-99.

13. bell hooks, 'marginality as site of resistance,' in Russell Ferguson et al [eds], Out There: Marginalization and Contemporary Culture, New York: The New Museum of Contemporary Art, and Massachusetts: MIT Press, 1990, pp 341-343.

14. Michel de Certeau, op cit, pp 23, 70.

15. Gilles Deleuze and Félix Guattari, Kafka: Toward a Minor Literature, trans. Dana Polan, Minneapolis: Minnesota University Press, 1986, pp 16 –19, 85.

16. Shaheen Merali, Foreword to the exhibition catalogue Crossing Black Waters, London: Panchayat and Working Press, 1992, p 5.

17. Walter Benjamin, 'The Storyteller,' in Illuminations, trans. Harry Zohn, New York: Schocken Books, 1968, p 89.

18. The Travelling Gallery was an initiative set up by the Scottish Arts Council to enable contemporary art to be seen outside the main city centres.

19. For the ancient Greeks 'barbarian' meant 'stutterer,' that is, someone who didn't speak the Greek language correctly. At some point 'barbarian' is opposed to 'civilised' and, during the colonial period, the de-humanising position assigned to the 'native' as justification for the West's 'civilising mission,' which was and

continues to be advanced, as we know, by unconscionable barbarous acts. But the 'barbarian-stutterer' remains an unconscious sign in the Western urban context.

20. Exhibited initially at the Harris Museum, Preston, Castle Museum, Nottingham as part of 4 x Four.
21. Part of the Angel Row, Nottingham, touring show.
22. Exhibited initially as part of Crossing Black Waters.
23. The minority Tamils were brought into Sri Lanka by the Portuguese and British as cheap labour for tea plantations.
24. 'It pays to buy good tea' is a slogan Merali found stamped on Brooke Bond tea chests. What troubled Merali about British tea, as with other products, was that they were blends from different localities, which was a means by which produce from countries like South Africa under official boycott were still able to circulate in the global markets.
25. The Irish potato famine of the 1840s and the reduction of a thriving Bengalese international cotton industry to jute production are other famous examples. The story behind It Pays to Buy Good Tea is that the embattled Tamils put out disinformation that the tea had been poisoned, hoping that the West would slap an embargo on Sri Lanka's only cash crop and force a resolution to the crisis.
26. Exhibited at Gallery 101, Ottawa, Canada.
27. First exhibited in Beyond Destinations, Ikon Gallery, Birmingham.
28. Hito Stereyl, 'Lacrimosa,' in Springerin, Austria, April/June, 2000, p 22-23.
29. Manthia Diawara, 'The Blackface Stereotype,' in Blackface, (ed) David Levinthal, Santa Fe: Arena Editions, 1999.
30. The painting depicts the notorious case in 1783 of the slaver Zong that was beset by an epidemic; since the Captain could claim insurance from cargo lost at sea but not through disease, he took advantage of a storm to throw overboard some 122 sick Africans. It became a cause célèbre for Abolitionists.
31. Dark Matters had been scheduled to coincide with a conference in Vienna on cultural difference at which several black British critics were invited to speak. These eventually boycotted the event following the success of the Freedom Party, but Merali decided to go ahead with the show, feeling that to confront the fascist position head-on was preferable to silence.
32. Susan Stewart, On Longing: Narratives of the Miniature, the Gigantic, the Souvenir, the Collection, Durham and London: Duke University Press, 1993, p 172.
33. Shaheen Merali, 'DigNative,' in catalogue to the exhibition Empire and I, London: Terra Incognita, 1999.
34. Stewart, op cit, p 66.
35. Colored Folks is in part a reworking of the performance by Ulay and Abramovic in which the couple stood naked in a narrow corridor where people had to decide whom they faced as they passed through, which, according to the performers, indicated the nature of their unconscious desire.
36. The documentation of the performance and accompanying workshop forms the subject of Colored Folks Video, 2002.
37. Maharaj, op cit, p 34.
38. A summary of some of the points in Gilles Deleuze and Félix Guattari, A Thousand Plateaus, trans. Brian Massumi, London: Athlone Press, 1988.
39. Fanon, op cit, p 231.
40. Peter Mason, Deconstructing America, London and New York: Routledge, 1990, pp 181-185.

DOB. 6th March 1959.
Place of Birth : Dar-es Salaam, Tanzania.
Lives and works in London and Berlin.

ONE PERSON EXHIBITIONS

Selected
CV

2001
Dark Matter II, Art Exchange, Nottingham.
U blow me away, Window Gallery, Central Saint Martins', London.

2000
Dark Matters, Kunsthalle Exnergasse, Vienna, Austria.

1999
Paradigms Lost, Travelling Gallery, toured North and East Scotland as part of
Fotofeis 95. Commissioned by Scottish Arts Council.

1994
Torchlights, Brick Lane Police Station, East London. Commissioned by the
Whitechapel Art Gallery.

1993
Channels, Echoes & Empty Chairs, Angel Row Gallery, Nottingham and South London
Gallery, London. Commissioned by Angel Row Gallery.

GROUP EXHIBITIONS

2002
Hygiene at the London School of Hygiene and Tropical Medicine, London.
(Curated by Pam Skelton and Tony Fletcher).
Site & Sight, Asian Civilisation Museum, Singapore. (Curated By Binghui Huangfu).

2001
A Man, A Woman, A Machine, Centre of Attention, London.
Host, Hastings Gallery and Museum. (Curated by Mario Rossi).
Dressing, Readdressing, collaboration with Mai Ghoussoub. Al-Saqi Books,
London.
Whats wrong?, The Trade Apartments, London
The Globe, Centre Beirut, Lebanon.
(Curated by Dave Beech).
Colored Folks, (performance) Toynbee Hall, London.
(Collaboration with Oreet Ashery).
Chanting Heads CD Rom, Curated by David a Bailey & Sonia Boyce, AAVAA.

2000
Ubudoda, Metropolitan Gallery, Cape Town, South Africa.
URL:http://www.ava.co.za/p/MERALI.html

1999
Machos y Muecas, La Casa Elizade, Barcelona. (Catalogue).
Empire and I, Pitshanger Museum and Gallery, London. And AXIOM centre,
Cheltenham. (Catalogue).
The Crown Jewels, Kampnagel, Hamburg and NGBK, Berlin. (Catalogue).
http://www.undo.net/cgibin/openframe.pl?x=/artinpress/949705200.951426662.
html
Zero Zero Zero, Whitechapel Art Gallery, London.
Men and Masculinities, James Hockey Gallery, Surrey Institute of Education,
Farnham, Surrey.
Out of India, Queens Museum, Flushing Meadows, New York, USA. (Catalogue).
http://www.queensmuse.org/shop/india.html
Transforming the Crown, Bronx Museum of Art, New York, USA. (Catalogue).
http://colophon.com/arts-x/caribctr/intro.html
Translocation, Photographers Gallery, London and Institute for Research on
the African Diaspora and Caribbean, City College of New York.
Alien/Nation, Sixpack Films, Vienna, Austria. (Catalogue).
Box Project, The Museum of Installation, London, Turnpike Gallery, Leigh and
Angel Row Gallery, Nottingham. (CD Rom Catalogue).

VIDEO SCREENINGS

Colored Folks (18 mins)
2002
Colored Folks video and photographs (collaboration with Oreet Ashery).
National Review of Live Arts.

Paradigms Lost Pt. 1 (5 mins 10 Secs)
1999
The post-colonial cities, curated by inIVA. The Lux Cinema, London.

1998
Exploding Cinema, Kennington, London.

1997
Pandemonium, ICA, London; Rotterdam 97-26 Film festival, Holland; Desh
Pradesh, Toronto, Canada; Whitechapel Open, Curtain Rd Gallery, London; KIZ-
Kino, Granz, Austria; Scratch Projection, Paris, France; Tokyo 97-Image Forum,
Festival, Tokyo, Japan; Pesaro 97-Film Festival, Roma, Italy; Hamburg 97-13.
International Kurzfilm-Festival & No., Hamburg, Germany; Jerusalem 97-Film
Festival, Jerusalem, Israel; Sao Paolo 97-Short Film Festival, Sao Paolo, Brazil;
Austin 97. Cinematexas- Int. short film + video + new, Austin, USA.

I loose my voice in my dreams (45 mins)
1994
Galerie 101, Ottawa, Canada.

1993
South London Gallery, London.

SELECTED WRITINGS ON SHAHEEN MERALI / EXHIBITIONS

2002
Hiroko Hagiwara. Black-Struggles over 'Race' and Gaze. June 2002. Tokyo
MAINICHI Newspaper Co Ltd. ISBN 4-620-31539-7.
pp. 254-265.

2001
Pierre Abisaab. Al-Wasat. No.494. 16/7/01.

2000
Rainer Unruh. Das Schicksaldes Geldes. Kunstforum International, Germany.
Jan- March pp. 344.
Jana Sittnick. Siebzehn jahr, Wonderbra. Frankfurter Allegmaine, Berliner
Seiten, 22.2.00.
Von Harald Fricke. Die zwei Seiten des Stereotypes. TAZ 25.2.00.
www.welt.de/daten/2000/02/08 Blonde Barbie im Sari
Lloyd Pollak. Artists peel away masculinity. Cape Times, S. Africa Oct. 25th.
Eddie Chambers. Crowning folly. Art Monthly, Gt. Britain. pp 56-57 April.
Hito Sweryl. Lacrimosa. Springerin. Austria pp 22-23 April-June.

1999
Francesco Bombi-Vilaseca. Ser hombres, hoy. La Vanguardia,
Barcelona, 20 Nov.
Victor Jeleniewski Seidler. Machos y Muecas (catalogue) Images,
Masculinities and Difference. University of Westminster. ISBN 185919 1150.
Richard Hylton. Art Monthly. Global v Local. 10.99. pp. 7-10.
Stewart Martin. Radical Philosophy 95. Empire and I. May/June 1999.

1998
Anne Doran. Time Out, New York. Raga Saga. A look at the art of the
subcontinent. Issue 123.
Edie Jakes. Q Guide. New York. 'Out of India'. Jan 15. pp. E1 and E13.
Lavani Melwani. India Today. Shades of Colour. March 2.
Mceveilley, Thomas. Art in America Tracking the Indian diaspora. (Various
artists of South Asian origin, Queens Museum, New York, Issue: Oct, 1998).
http://www.findarticles.com/cf_0/m1248/n10_v86/21250048/p1/article.jhtml
?term=

SELECTED WRITINGS BY SHAHEEN MERALI

2002
'Panchayat,' interarchive, editor Hans Ulrich Obrist, Kunstraum der
Universitat Lunenburg, Verlag der buchhandlung Walther Konig, Koln, 2002.
ISBN 3-88375-540-0 pp 276-280.
Claiming Multiple Identities, ISIM Newsletter 10/02, The Netherlands (with
Mai Ghoussoub) & Abwab 31 ISSN 1354-3857.
Anthology of art, Jochen Grez project on the web, What is your vision of an
unknown art? www.anthology-of-art.net

2001
'Going Native: revisited' in Beyond Frontiers: Contemporary
British Art by Artists of South Asian Descent. Amal Ghosh and Juginder
Lamba, eds. London: Saffron Books (Eastern Art Publishing), 2001,
ISBN 1 872843 21 2.

1997
Publication contribution: for Donald Rodney at the South London Gallery,
Funded by ACE. 10th Sept. 97.

CATALOGUE ESSAYS

Displaces, exhibition by Mai Ghoussoub and Souheil Sleiman, Saqi publication,
London.
Technology: Detection or Deception. Endword. Radical Postures. Panchayat
Publication. ACE Funded. Spring 1998.
Catalogue essay for Eric Soeutre, France.
Editor and contributor to Carte Blanche / the white papers, Lethaby Press/
Panchayat. ISBN 0946282 62 5.

REVIEWS

Third Text, England. ISSN 0952-8822.
Under Different Skies (Issue 37).
Displaces (Issue 39, Summer 97).
Texaco (Issue 40, Autumn 97).
Extravagant strangers, Issue 41,Third Text.
Kay Hassan. Issue 55, (Summer 01).
Review: Al-Hayat newspaper (London & New York).
South Africa and Kay Hassan.
Extravagant Strangers edited by Caryl Phillips; Texaco by Patrick
Chamoiseau; Ethnicity by John Huthinson and Anthony D. Smith.

ESSAY

Kilts, Lungi and Dishdash. Men wearing skirts? Abwab, Int. Arab quarterly. No.
15. ISSN: 1354-3857.
Work / Illustrations: Achillies Heels, London. No. 21 & 22. (Spring & Summer /
Summer & Autumn 97) ISSN 0141-2752.

CURATED PROJECTS

2002
Ford, Oxford House, Ashley Gardens and I&I, 3 East London galleries.
Post graduate students Central Saint Martins School of Art and Design.

2001
Martin, Spitz Gallery, London. Post graduate students Central Saint Martins
School of Art and Design.
Local Artists, Al-Saqi Bookshop, London, an exhibition of International
artists living in W2, London, incl. Anna Thew, Robert Taylor, David Medalla,
Caryle Reedy, Tina Keene.

1999-2000
Slow Release, Bishopsgate Goodsyard, London (co-curator), an exhibition of
three artists around the notion of the garden. (Dinh Q.Le, Simryn Gill and
Edwina Fitzpatrick).

1999
Unbound Geographies, FUSED HISTORIES, Lethaby Gallery, London, an exhibition of four artists (Simon Tegala, Tanya Syed, Jin-Min Yoon and Enam Huque). Tim Sharp, Central Saint Martins, London.
Liz Ellis, Central Saint Martins, London.

1999
Foreign Vienna. University of Westminster Gallery, London. Photographic record of the changing demographic population of Vienna. Videobox. University of Westminster Gallery, London. Video works by Black and Asian artists from Panchayat's archive.

1998
UNBOUND HISTORIES, fused geographies. A Space, Toronto, Canada. Sept. An exhibition of four artists (Simon Tegala, Tanya Syed, Jin Min Yoon & Enam Huque) of Asian origin in two countries. Co-curated with Shelly Bahl and Marilyn Jung. Xenographic views: An exhibition of photographs by Austrian artist Lisl Ponger as part of the Central European Festival of Culture. June 9th–July 3rd M.A.
Space. Central Saint Martins College of Art and Design.

1996
Gender and its multiplicities. Watermans Arts Centre, London.
Video screening around masculinity by Michael Petry, Man Act, Sarbjit Samra, Ming Ma and Keith Piper.
Clare Robins. Commercial Gallery. London. Inaugural show at east London gallery. Richard Graville. Commercial Gallery. London. Solo show by a London artist working with violence and conceptual painting.

1995
Insurgent voices. Gallerie 101, Ottawa, Canada, Asian American artists working with HIV/AIDS, RACE/ ETHNICITY. Installations by Ming Ma & Ken Chu and video works by Tran T. Kim Trang.
Samena Rana. Diorama Centre, London. Posthumous exhibition by (dis)abled photographer originally from Pakistan.

1994
Extreme Unction HIV/AIDS, RACE/ ETHNICITY performances and installations by Asian American artists Dan Kwong, Monica Chau, Paul Pfeiffer and Ken Chu. The Garage, East London. Screenings by Asian American film-makers at the National Film Theatre incl. Tran T. Kim Trang.

1993
Forensic Fictions, ICA, London, co-curated performance with Stuart Taylor.

1990–1991
One person shows by Tam Joseph, Chila Kumari Burman, group show from South Africa, Artists with (dis)abilities. One Spirit Gallery, Haringey, London.

1990
Crossing black waters. City Gallery, Leicester, Cartwright Hall, Bradford, Oldham Art Gallery and Museum, Oldham and South London Gallery, London. Mixed media exhibition by eleven artists from India, Pakistan and Britain interrogating post-Independence issues. Artists include Samena Rana, Said Adrus, Bhajan Hunjan, Anwar Saeed, Allan de Souza, Qurdus Mirza and Arpana Caur.
Siting resistance, Embassy Cultural House, London, Ontario, Canada. Artists Sonia Boyce, Keith Piper, Allan de Souza, Pitika Ntuli and Shaheen Merali. Co-curated with Jamelie Hassan and Ron Banner.

1989
Five black British artists, Havana Biennale, Cuba. First intervention by Black artists from Europe at the Havana Biennale. Artists Sonia Boyce, Keith Piper, Allan de Souza, Pitika Ntuli and Shaheen Merali.
Distinguishing marks. Black artists group show at the Bloomsbury Gallery, Institute of education, London. Artists Sonia Boyce, Keith Piper, Allan de Souza, Pitika Ntuli and Shaheen Merali.

Acknowledgments

Pamela, Alisha and Zara — many thanks
Anis, Tasneem, Sameen, Papa and
Shafiq—4ever

The Merali Clan, the Wood Clan, BSSK,
the Staff at Central Saint Martins',
the University of Westminster and
the future HKW.

Special thanks to the contributors,
the funders, Paul Khera, Yer and Mr Beech

Be passionate about the future.
merali@hkw.de

British Library Cataloguing—in—
Publication Data
A catalogue record for this book is
available from the British Library.

ISBN 0 86356 708 8

This edition first published 2004
Saqi Books
26 Westbourne Grove
London W2 5RH
www.saqibooks.com

Central Saint Martins
College of Art & Design

THE LONDON INSTITUTE

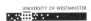

UNIVERSITY OF WESTMINSTER

B1-3
"Channels, Echoes & Empty Chairs", (1993)
a series of fifteen duratran, digitally
manipulated images; sound triggered
compositions and samples accompanied by
event astrology of objects (By Dr. Doug
Smith). Angel Row Gallery, Nottingham and
South London Gallery, London. Commissioned
by Angel Row Gallery. (Collaboration with
Philip Chambon)

B4-7
"Paradigms Lost" (1995) Travelling Gallery,
toured North and East Scotland as part of
Fotofeis 95. Commissioned by Scottish Arts
Council.
plus video: "Paradigms Lost Pt. 1" (5 mins 10
Secs)
Selected screenings include:
1999. The post colonial cities, The Lux
Cinema, London.
1997: Pandemonium, ICA, London; Rotterdam
97-26. Filmfestival, Holland;
KIZ-Kino, Granz, Austria; Tokyo 97-Image
Forum, Festival, Tokyo, Japan.

B8-11
"It pays to buy good tea" (detail).
installation using large waxed screens ,
teabags, teachests, slide projections and
photographs. (1991) exhibition:
4 x Four, Harris Museum, Preston and Castle
Museum, Nottingham. Curated by Eddie
Chambers. (catalogue)

B12-13
"Kempfire", installation using large format
slide, 35mm positive, kinder suprise figures,
blacked out photographs, mini lightbox and
vitrine. (2000)
B14-17
"Dark Matters", a series of site specific
installations at the Kunsthalle Exnergasse,
Vienna, Austria, (2000) as a response to the
advent of the 'Freedom Party' in Austria.
Curated by Tim Sharp / Lisl Ponger.

B20-26
Colored Folks video and photographs
(collaboration with Oreet Ashery) 2000
2002, National Review of Live Arts. Glasgow
2001, A Man, A Woman, A Machine,
Centre of Attention, London;
Colored Folks, (performance) Toynbee Hall,
London. Photographs: Oficina Humana

A1-7
"digNative" (1999) Installation using four
Victorian Mahogany vitrines, negrophilia
objects and storage materials.
exhibition: Empire and I, (curated by Alana
Jelenik) Pitshanger Museum and Gallery,
London. And AXIOM centre, Cheltenham (cat.)

A8-11
"Going Native" (1992) Installation using
video projection, slide projections, deck
chairs and composed soundtrack.
exhibition: Trophies of Empire, Bluecoat
Gallery, Liverpool and the Arnolfini, Bristol.
(catalogue) curated by Keith Piper.

A12-15
"Falling Space- Naomi" black photographic
paper collage-lifesize (2001)
Dark Matter II, Art Exchange, Nottingham.
"Michael-Resisting" black photographic
paper collage-lifesize (2001)
Dark Matter II, Art Exchange, Nottingham.

A16-19
"untitled- Erotic terrorism" 1999
unpublished digitally manipulated images of
negrophilia and ethnic other - part of a
collection of 2000.

A20-23
"After the Deluge" 2002
Photocopies, brown tape, recycled bottles,
water, cardboard boxes, School of Hygiene
and Tropical Medicine, London. Curated by
Pam Skelton and Dr Tony Fletcher.
www.lshtm.ac.uk/art/hygiene/merali.html.

A23-24
"Fire, Theft and Acts of Gods", (1991)
Installation using wax resist paintings of
the elements with fired ceramic components
and four elements-water, earth, air and ash.
Angel Row Gallery touring Show in
Nottinghamshire.

A26-27
Confrontations, 1993
an installation using portraiture / self
portraiture of Bengali children in the
borough of Camden as part of the residency
at South Camden School (Sir John Cass
Foundation) and personal collection of
postcards of the 'other'. Walsall Gallery And
Museum, Walsall. (catalogue) Curated by
Deborah Robinson.

A28-30
"Its Cheap to run" 2000
large monochrome indoor inflatable.
Commissioned by Apna Arts / East Midlands
new works Commission.
2002, Site & Sight, Asian Civilisation Museum,
Singapore. Curated By Binghui Huangfu
2001, Dark Matter II, Art Exchange,
Nottingham. Host, Hastings Gallery and
Museum.(curated by Mario Rossi / Judith
Stewart)
2000, Ubudoda, Metropolitan Gallery, Cape
Town, South Africa (curated by MIG)

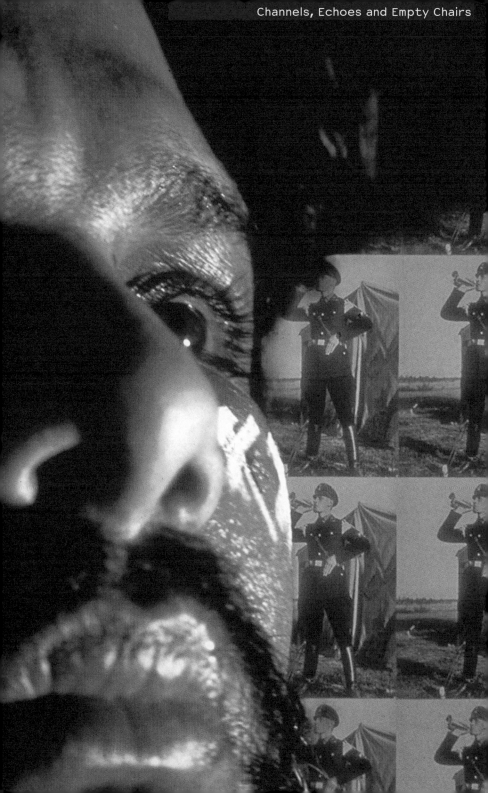

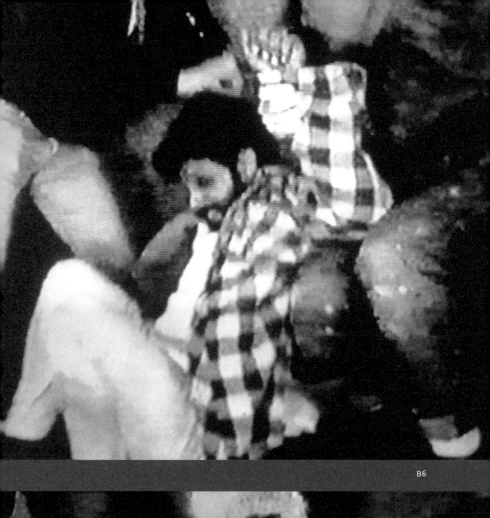

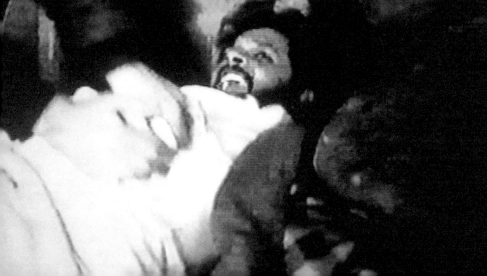

It pays to buy good tea

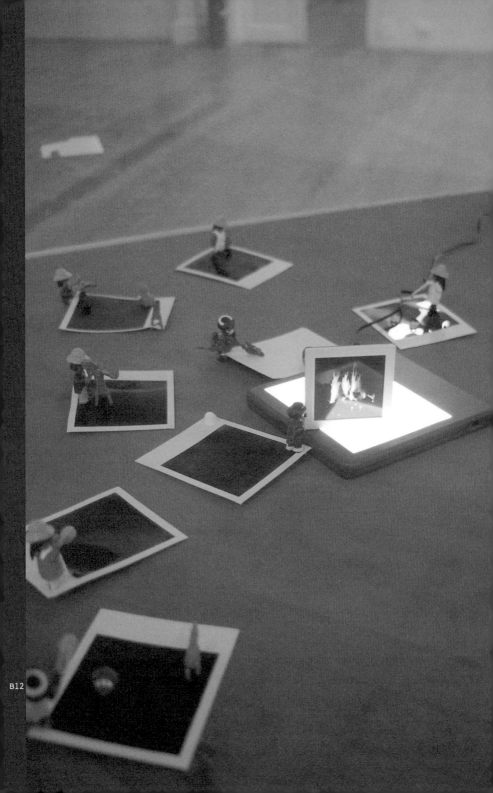

Kempfire

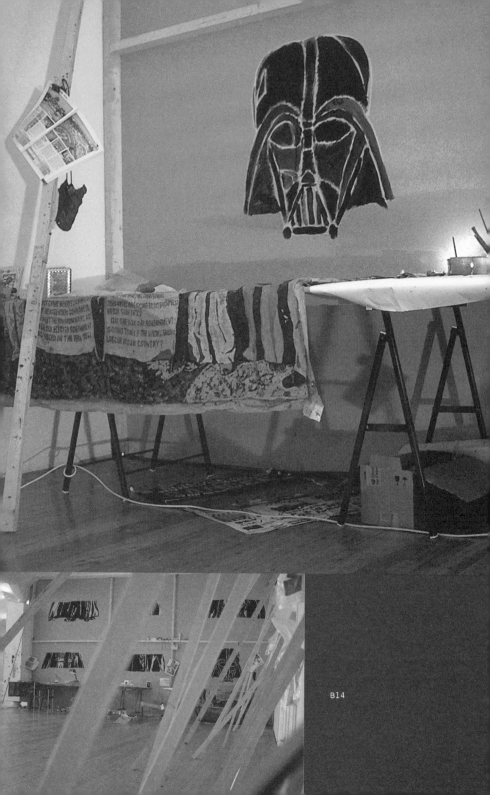

B14

HEISS
HOT

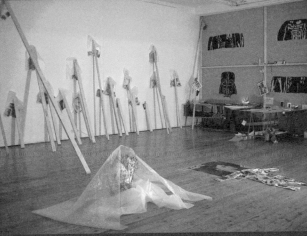

Dark Matters

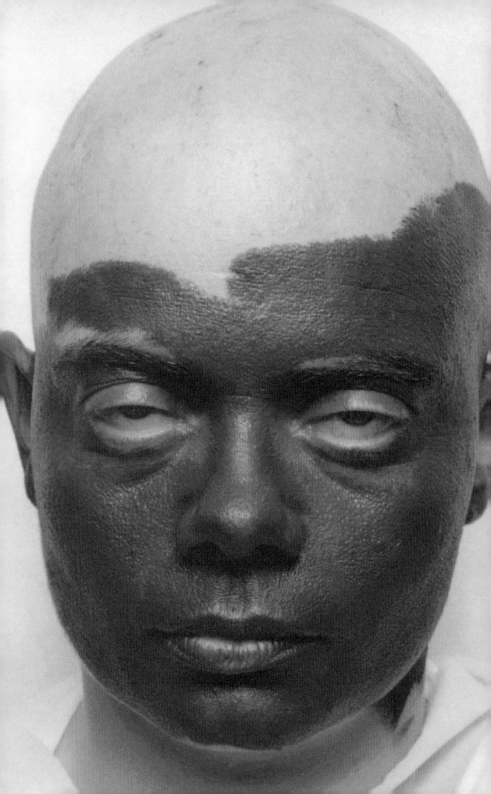

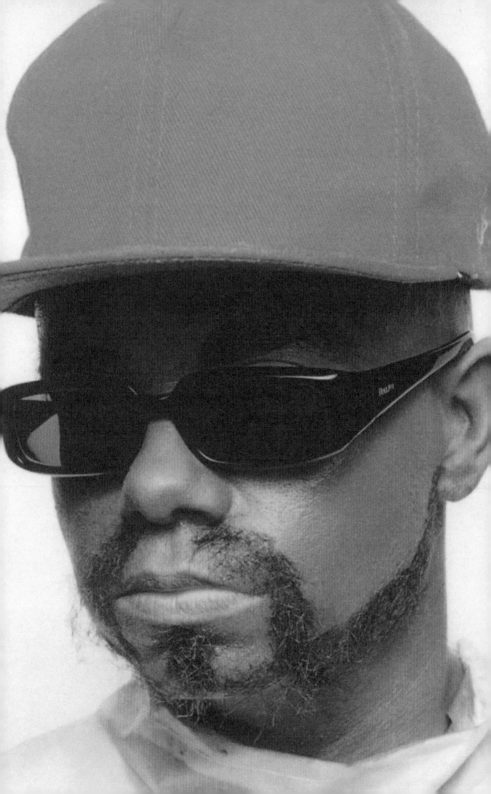

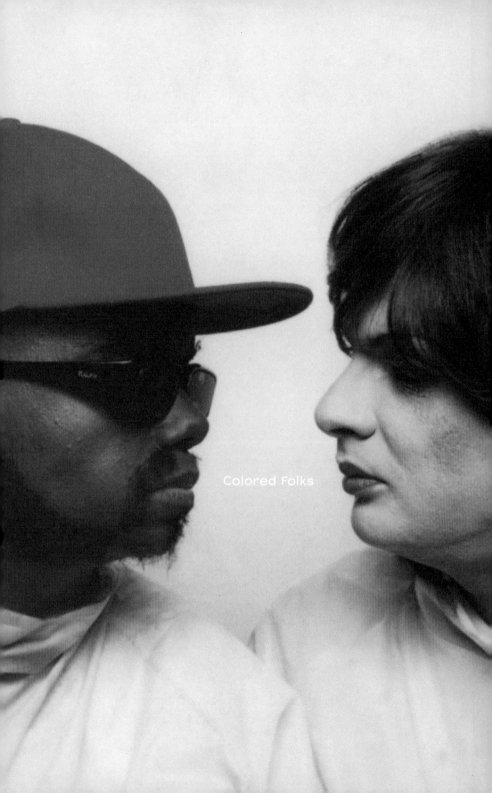

Colored Folks